Images of America

of America

TITUSVILLE AND MIMS

Ace
474 6454 Rinrside

IMAGES
of America

TITUSVILLE
AND MIMS

Benjamin D. Brotemarkle

ARCADIA
PUBLISHING

Published by Arcadia Publishing
Charleston SC, Chicago IL, Portsmouth NH, San Francisco CA

Printed in the United States of America

Library of Congress Catalog Card Number: 2003116533

For all general information contact Arcadia Publishing at:
Telephone 843-853-2070
Fax 843-853-0044
E-mail sales@arcadiapublishing.com
For customer service and orders:
Toll-Free 1-888-313-2665

Visit us on the Internet at www.arcadiapublishing.com

This book is dedicated to my wonderful wife Christina and to my students at Brevard Community College, past, present, and future.

CONTENTS

ABOUT THE AUTHOR

Ben Brotemarkle is the author of the book *Beyond the Theme Parks: Exploring Central Florida*, a look at historic preservation efforts and cultural festivals throughout the region that provide residents with a sense of community and visitors with interesting vacation options. The book received the inaugural James J. Horgan Book Award from the Florida Historical Society. His forthcoming book—*Crossing Division Street: A Portrait of the African American Community in Orlando, Florida*—is an interdisciplinary examination of the past, present, and future of a historic neighborhood. Dr. Brotemarkle is an associate professor of humanities and the department chair at Brevard Community College in Titusville. As producer and host of the weekly public radio program *The Arts Connection* on 90.7, WMFE-FM Orlando, from 1992 to 2000, Brotemarkle covered the local arts and cultural scene, including theater, music, dance, film, the visual arts, and literature. His award-winning features have been heard around the world on Voice of America Radio, across the country on National Public Radio, and throughout the state on Florida Public Radio. Brotemarkle also occasionally produces and hosts special programs for public television. His 1999 television documentary, *The Wells' Built Hotel: A New Guest Checks In*, was awarded the Presidential Citation of the Florida Historical Society. Currently, Brotemarkle is producer and host of the radio magazine *Culture Quest* on 89.5, WFIT-FM, Melbourne. As a part-time professional singer-actor, Brotemarkle has appeared in more than two dozen Orlando Opera Company productions, with Seaside Music Theater in Daytona Beach, and as a featured performer in *Cross and Sword*—the official state play of Florida in St. Augustine. A board member of the Association to Preserve African American Society, History, and Tradition (PAST, Inc.), Brotemarkle helps to plan, present, and promote activities and exhibitions at the Wells' Built Museum of African American History and Culture in Orlando. Dr. Brotemarkle is the education committee chairman for the Moore Heritage Festival of the Arts and Humanities, organizing student workshops, public forums, oral history panels, and appearances by guest speakers. Brotemarkle has a Ph.D. in humanities and history from the Union Institute and University, a master of liberal studies degree and a bachelor of arts degree in humanities from Rollins College, and an associate degree in voice performance from the Florida School of the Arts. Ben Brotemarkle lives in Titusville with his wife Christina.

INTRODUCTION

The area that is now Titusville, Florida, and the adjacent town of Mims has a fascinating and unique history. The community is home to a prehistoric graveyard discovered in one of the most important archaeological excavations anywhere in the world. As pioneers settled the wilds of Central Florida in the mid-1800s, colorful characters such as Col. Henry Titus staked claims here. Titus won the right to name a town after himself through his skill at playing dominoes. More than 12 years before the murder of Medgar Evers, 14 years before the killing of Malcolm X, and 17 years before the assassination of Dr. Martin Luther King Jr., a bomb exploded under the Mims home of educator, activist, and NAACP leader Harry T. Moore, making him the first martyr of the contemporary Civil Rights movement. When the United States entered the Space Age in the 1960s, the residents of Titusville and Mims became workers for NASA and have since enjoyed front row seats to the launch of every manned American space flight up to the present day. From the discovery of amazingly well preserved, 8,000-year-old human remains through the growing pains of the American South to the hopes for the future offered by our exploration of space, Titusville and Mims have made international headlines from Miami to Moscow.

Located about 40 miles east of Orlando, 50 miles south of Daytona Beach, and 45 miles north of Melbourne, Titusville and Mims are on Florida's east coast, just across the Intracoastal Waterway from the Kennedy Space Center. NASA's Vehicle Assembly building, one of the most voluminous buildings in the world (second only to the Boeing facility in Washington state) can be clearly seen from U.S. Highway 1, which runs through both Titusville and Mims. Unlike many cities that have been enveloped in the urban sprawl of Central Florida, Titusville and Mims retain a comfortable small-town feel and a strong sense of community. Even as the population of the area swells, with thousands of new families moving here each year, an awareness of local history can help to perpetuate a sense of community well into the 21st century.

We begin this look at the history of Titusville and Mims in chapter one, Ancient History, an exploration of the prehistoric culture uncovered during the Windover Archaeological Dig in 1984 and the lives of the area's other Native American people. Chapter two, Creating a Community, examines the accomplishments of pioneers, settlers, and developers in the late 19th and 20th centuries. Chapter three brings us to School Days, detailing life at educational institutions such as Mims Public School, Titusville High School, Astronaut High School, and Brevard Community College. Chapter four, Arts and Culture, gives us tickets to Titusville Playhouse performances in the Emma Parrish Theater, performances of the Brevard Symphony Orchestra, and diverse multi-cultural events. In chapter five, Sports and Leisure, we see boating, fishing, hunting, tennis, golfing, baseball, and other fun activities of the past century. We go Back to Nature in chapter six, exploring the area's beaches, wilderness, and wildlife. The Indian River provides both work and recreation to local residents, as we will see in chapter seven, On the River. In chapter eight, Be Our Guest, we visit historic hotels and look at some interesting visitors to the area. The Harry T. Moore Legacy discussed in chapter nine depicts the life of this Civil Rights martyr from Mims. Finally, chapter ten shows us why Titusville is known around the world as Space City, U.S.A.

ACKNOWLEDGMENTS

This work was made possible by research and the collecting of historic photographs undertaken by others. The author particularly thanks the following people and organizations for providing information and images to be collated for this project: Nick Wynne and the Florida Historical Society, Debra Wynne and the Alma Clyde Field Library of Florida History, Roz Foster and the Brevard County Historical Commission, Joe Merckson and the North Brevard Historical Museum, David N. Rich and Evangeline Moore of the Harry T. and Harriette V. Moore Cultural Complex, the Brevard Museum of History and Natural Science, Bob Hudson and the *Star Advocate* newspaper, Stacy E. Johnson and the Titusville Playhouse, Mary Nelson and the Brevard Symphony Orchestra, the Florida State Archives, NASA, and the faculty and staff of Brevard Community College, including Dr. Laurence Spraggs, Sandy Handfield, Dyan Beynon, Joanne Connell, JoAnn Fosbenner, and Jill Simser. The author's wife, Chris Brotemarkle, made substantial contributions to this project. Thanks also to Barbie Langston and the staff of Arcadia Publishing.

Additional sources include:

Ball, Jim, et al. *History of Brevard County Vol. 3: Photographic Memories.* Stuart, FL: Brevard County Historical Commission, 2001.

Brotemarkle, Benjamin D. *Beyond the Theme Parks: Exploring Central Florida.* Gainesville: University Press of Florida, 1999.

Doran, Glen H. *Windover: Multidisciplinary Investigations of an Early Archaic Florida Cemetery.* Gainesville: University Press of Florida, 2002.

Faherty, William Barnaby. *Florida's Space Coast: The Impact of NASA on the Sunshine State.* Gainesville: University Press of Florida, 2002.

Franklin, John Hope and Alfred A. Moss Jr. *From Slavery to Freedom: A History of African Americans, 7th edition.* New York: McGraw-Hill, Inc., 1994.

Gannon, Michael. *Florida: A Short History.* Gainesville: University Press of Florida, 1993.

Green, Ben. *Before His Time: The Untold Story of Harry T. Moore, America's First Civil Rights Martyr.* New York: The Free Press, 1999.

Manning, John T. and Robert H. Hudson. *North Brevard County.* Charleston, SC: Arcadia Publishing, 1999.

Shofner, Jarrell H. *History of Brevard County, Vol. 1.* Stuart, FL: Brevard County Historical Commission, 1995.

———*History of Brevard County, Vol. 2.* Stuart, FL: Brevard County Historical Commission, 1996.

Stone, Elaine Murray. *Brevard County: From Cape of the Canes to Space Coast.* Northridge, CA: Windsor Publications, Inc., 1988.

One

ANCIENT HISTORY

Howard Carter discovered the Egyptian burial chamber of King Tutankhamen in 1922, causing a media sensation. People around the world were intrigued by the antiquity of the preserved human remains from about 1300 B.C. and the artifacts that surrounded it. When a backhoe operator working on Titusville's Windover Farms housing development in 1982 first saw the skeletons he was uncovering, he had no idea that he had found human remains and artifacts about 3,200 years older than King Tut and about 2,000 years older than the Great Pyramids in Egypt. While the Florida Legislature originally denied funding for excavation of the Windover Archaeological Site, by 1984 a team of scientists and researchers from Florida State University were in Titusville carefully uncovering and studying the burial site that was determined to be between 7,000 and 8,000 years old.

International media declared the Windover Site "one of the most important archaeological discoveries ever made." Located about one mile southeast of the intersection of Highway 50 and I-95, the Windover Site was explored over three years, with three six-month field sessions uncovering not only human remains, but the oldest woven cloth ever found in North America, as well as tools and weapons made of animal bone and antlers.

In more recent centuries, Native American tribes, including the Ais and Seminoles, hunted and fished in the area that later became Titusville and Mims. As white settlers began moving to Central Florida in the early 1800s, the Native Americans were forced out of the region.

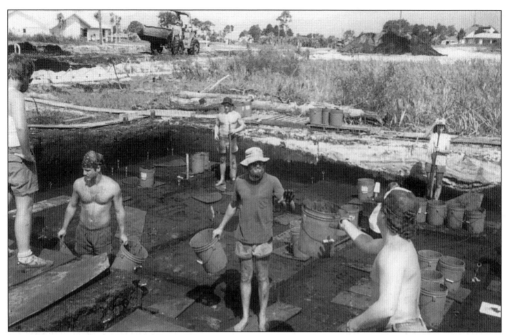

Archaeologists from Florida State University carefully explore the Windover Dig in Titusville. Funding for the Windover Archaeological Research Project was provided by a variety of sources, including the State of Florida, the National Geographic Society, IBM, the Jesse H. Ball Dupont Fund, the Ford Foundation, and the Gannett Foundation. (Courtesy of the Brevard County Historical Commission.)

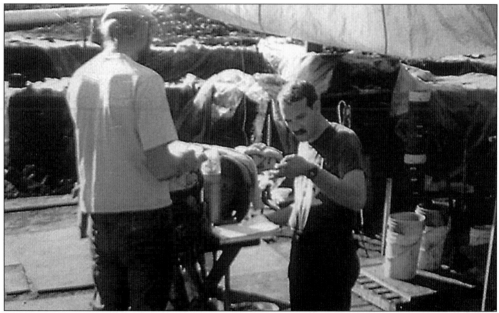

Archaeologist David N. Dickel (left) relocated to Central Florida from California to work on the Windover Dig. Dr. Dickel was invited to participate in the project by his college friend Dr. Glen Doran (right), who led the excavation. (Courtesy of the North Brevard Historical Museum.)

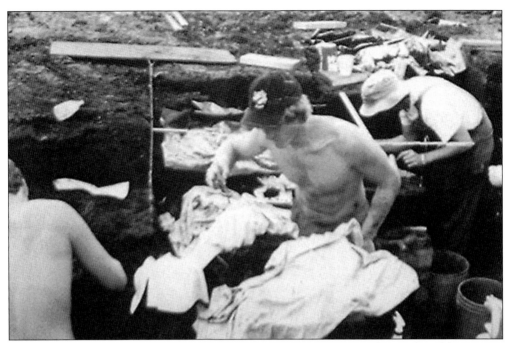

These workers at the Windover Dig uncover bones and artifacts for further study in laboratories. The remains discovered are of people believed to have originally traveled to this area during the Ice Age. (Courtesy of the North Brevard Historical Museum.)

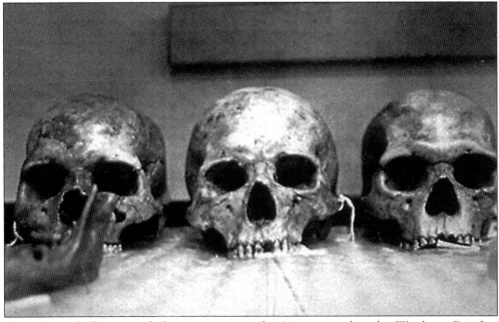

These three skulls, pictured above, are among the 91 uncovered at the Windover Dig that contained amazingly well-preserved brain tissue. The peat bog under the pond where the remains were discovered kept the brain matter and other soft tissue samples from deteriorating over seven millennia. The stomach contents of one ancient woman indicated that she had a meal of fish and berries before she died. (Courtesy of the North Brevard Historical Museum.)

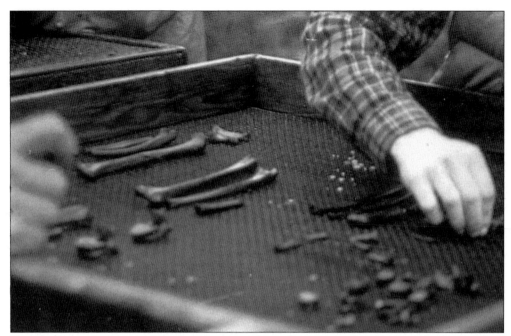

Excavation workers at the Windover site are shown here meticulously cleaning the bones of four small children in the wet screening area of the dig. About half of the remains found at Windover were children. One young woman died just a few weeks before she was going to give birth. One boy between 13 and 15 years of age had the painful disease spina bifida. The oldest people found were about 60 years old. (Courtesy of the North Brevard Historical Museum.)

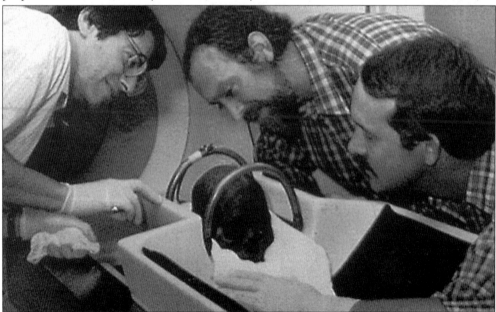

An unidentified technician (left) assists Dr. David N. Dickel (center) and Dr. Glen Doran (right) in scanning a skull from Windover. The preserved brain tissue found allowed scientists to run DNA tests on the prehistoric people and determine their familial relationships. (Courtesy of the North Brevard Historical Museum.)

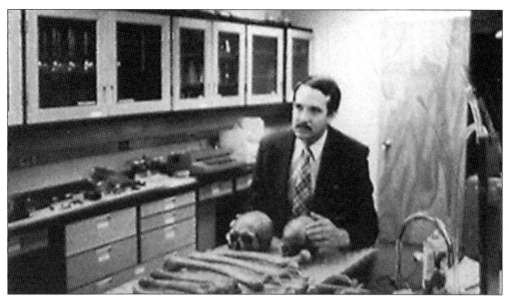

Dr. Glen Doran is shown here examining some of the bones and artifacts discovered at Windover. Dr. Doran praised the people of Brevard Community College for providing his archaeological team with lab space and making the researchers "feel at home." He also praised the staff of Wuestoff Hospital for allowing ancient soft tissue samples to be temporarily stored in their pathology lab's freezer. (Courtesy of the North Brevard Historical Museum.)

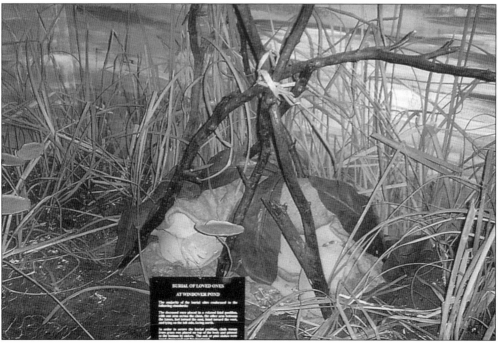

This display at the Brevard Museum of History and Natural Science demonstrates how most of the bodies discovered at the Windover Dig were buried. The bodies were deliberately positioned, wrapped in woven cloth, and held underwater with bound branches pushed into the wet ground. (Courtesy of the Brevard Museum of History and Natural Science.)

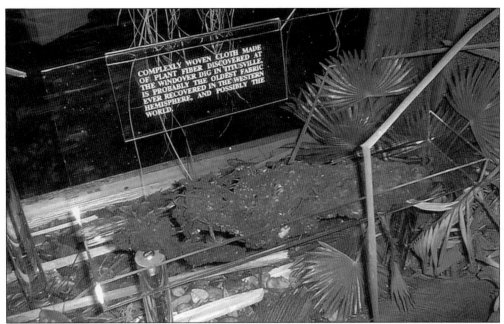

The plaque posted on this display at the Brevard Museum of History and Natural Science says: "Completely woven cloth made of plant fiber discovered at the Windover Dig in Titusville is probably the oldest fabric ever recovered in the Western Hemisphere, and possibly the world." (Courtesy of the Brevard Museum of History and Natural Science.)

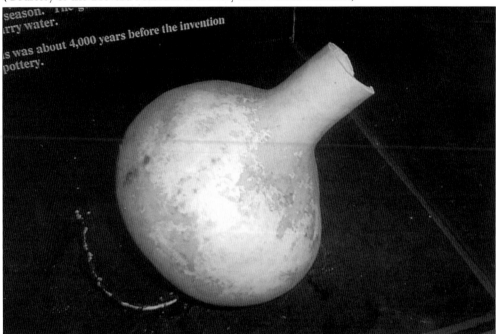

Bottle gourds, like the one pictured here, were discovered at the Windover Dig. The gourds, which require human intervention to grow, were dried and used as vessels to carry water. Tools and weapons made of antlers, manatee ribs, and other animal bones were also found. (Courtesy of the Brevard Museum of History and Natural Science.)

14

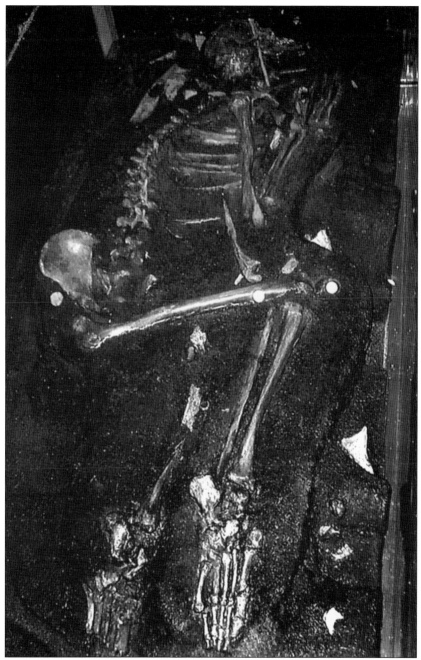

Many of the ancient skeletons uncovered at the Windover Site were ritualistically buried. As this photograph shows, the bodies were placed in a fetal position lying on the left side. The heads of the dead pointed to the west with their faces to the north. Only two bodies were found buried in an extended position as is customary today, and one of them was lying face down. The damaged and diseased condition of some of the bones buried at the site indicate that, unlike some tribal cultures, the people of Windover cared for all members of their society, even those who could not participate in hunting, fishing, and other activities essential to the survival of the group. (Courtesy of the Brevard Museum of History and Natural Science.)

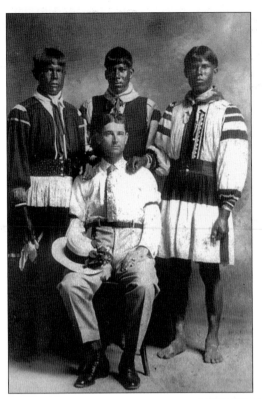

This unidentified white man from Titusville was photographed in about 1900 with three Seminole Indians. In the mid-1830s, the Second Seminole Indian War forced most of the indigenous population out of the area to allow settlers of European descent to move in. (Courtesy of the Brevard County Historical Commission.)

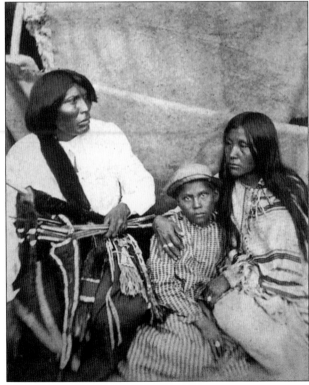

This Native American family was photographed in 1875. They were incarcerated at Fort San Marcos in St. Augustine, about 95 miles north of Mims, to make white settlers feel more comfortable. (Courtesy of Florida State Archives.)

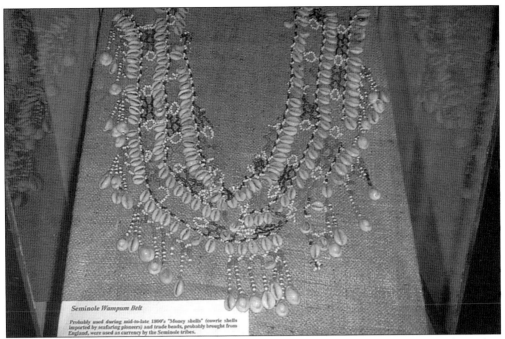

Seminole *Wampum Belt*

Probably used during mid-to-late 1800's. "Money shells" (cowrie shells imported by seafaring pioneers) and trade beads, probably brought from England, were used as currency by the Seminole tribes.

The Seminoles used wampum belts, like the one in this photograph, as currency in the 1800s. They were made with seashells and beads, probably brought here from Europe. (Courtesy of the Brevard Museum of History and Natural Science.)

The brightly colored clothing shown here is typical of that worn by Native Americans in Florida. This shirt is turquoise with a bright red stripe and gold, black, blue, and white accents. (Courtesy of the Brevard Museum of History and Natural Science.)

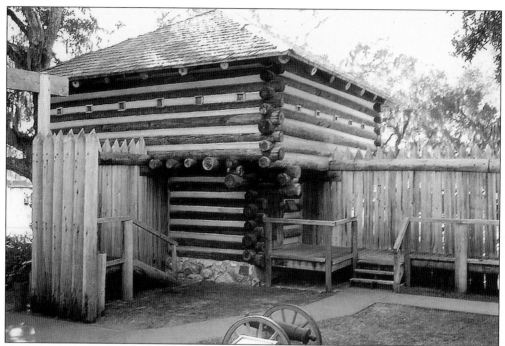

Fort Christmas was built in 1837 to protect American soldiers in the Second Seminole Indian War. A similar structure called Fort Ann was built the same year in the Titusville area. This replica of Fort Christmas, built in 1977 about one mile south of the fort's original location, is about 10 miles west of Titusville. (Courtesy of Fort Christmas Historic Park.)

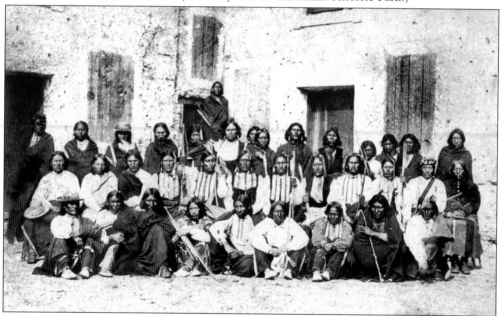

This 1875 photograph shows members of several Native American tribes imprisoned in St. Augustine, north of Titusville and Mims. A primary cause of the two Seminole Indian Wars was that Native Americans here protected runaway slaves from being recaptured. (Courtesy of Florida State Archives.)

Two

CREATING A COMMUNITY

Historians believe that when Spanish explorer Juan Ponce de Leon first arrived at the place he named "La Florida" (the land of flowers) in 1513; he came ashore about 50 miles south of Titusville and Mims, somewhere around Melbourne Beach. While living on Florida's coast, the Spanish planted orange groves that would play an important role in the future economy of the region. When England took control of Florida from the Spanish in the early 1760s, they labeled Florida "unconquerable." The United States had possession of Florida by 1821, and in the decades that followed, settlers gradually began moving in.

By the mid-1800s, the LaGrange community was established directly between what would become Titusville and Mims near the area known as Sand Point. Titusville was established in 1867 when Col. Henry Titus took control of large portions of land owned by his wife, Mary Hopkins Titus. Pioneers established homesteads in the area that would become Mims by the 1860s; the town was not called Mims until the 1880s, when it was named after the Mims brothers, Britton, Casper, and Robert. By 1885, the railroad terminals in Titusville and Mims and the Indian River Steamboat Company made the area the transportation hub of Florida's east coast.

Titusville and Mims benefited from the Florida "land boom" of the early 20th century. By the mid-1920s, there were thriving businesses in the bustling downtown area of Titusville, and by the mid-20th century the region was reaching for the stars.

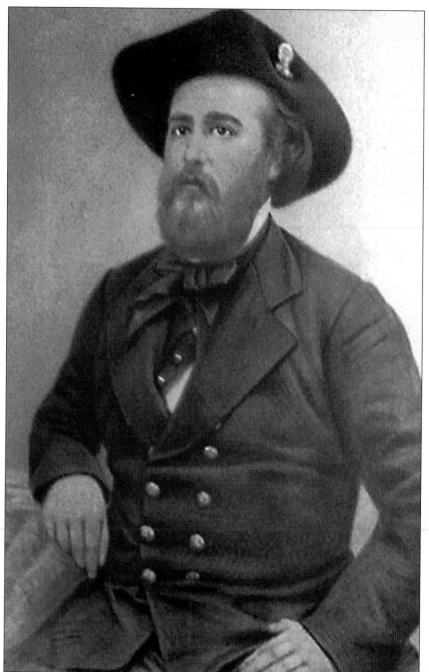

Col. Henry Titus was quite a colorful character. Known as a "soldier of fortune" before moving to Central Florida, Colonel Titus fought abolitionists in Kansas, participated in the revolution in Nicaragua, and assisted the Confederate Army in the American Civil War. While serving as postmaster of Sand Point in 1867, Titus played a game of dominoes that would allow the winner to rename the town. Titus won the game and renamed the town Titusville. Public buildings and churches were built on land donated by Titus and his wife. In 1880, Titusville was declared the seat of Brevard County. (Courtesy of the Alma Clyde Field Library of Florida History.)

The LaGrange Church is located on the border between Titusville and Mims. The church, built in 1869, is the oldest Protestant church south of St. Augustine and the oldest church south of New Smyrna Beach. The church pictured here was constructed in 1894 to replace the original building made of logs. (Courtesy of LaGrange Church.)

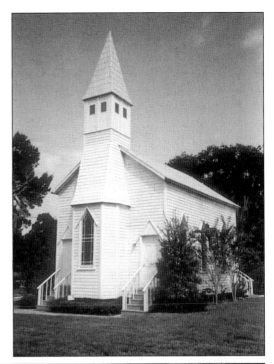

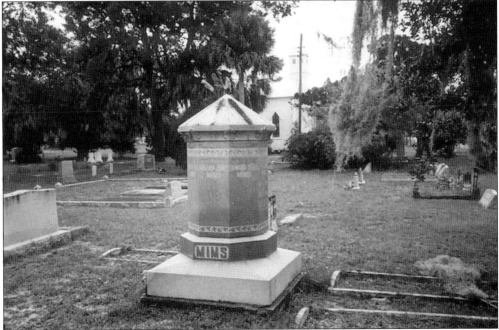

The Mims family tombstone is located in the LaGrange Church cemetery. The town of Mims was named after Britton J. Mims and his brothers Casper and Robert, who were law-abiding relatives of the infamous outlaw Jesse James. Henry Titus, who lived from February 13, 1823, to August 7, 1881, is also buried in the LaGrange Church cemetery. The oldest grave in the cemetery belongs to Andrew Feaster, who fought in the War of 1812. (Courtesy of LaGrange Church.)

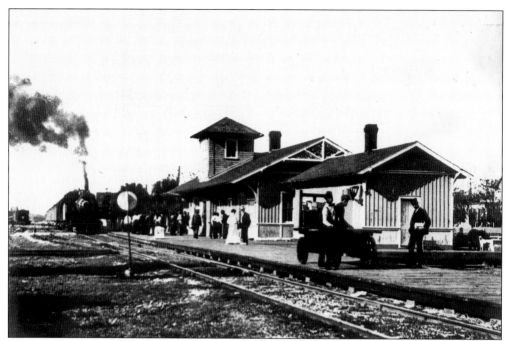

This photograph of the Titusville Railroad Depot was taken around 1900. The first railroad track in Titusville came from Enterprise and went down Broad Street. The track went onto a dock where steamships were loaded with cargo from the train. (Courtesy of Florida State Archives.)

Henry Flagler's Florida East Coast Railway came to Titusville in 1893. This allowed citrus, pineapples, seafood, lumber, and other goods from Titusville and Mims to be shipped to Northern cities. (Courtesy of Florida State Archives.)

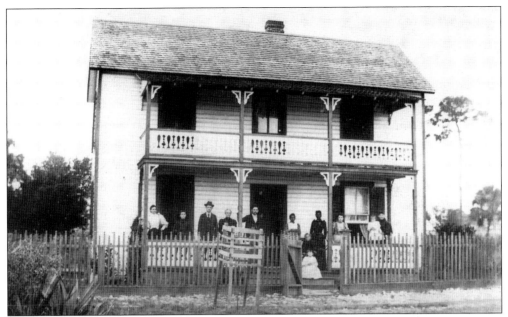

This photograph from 1883 shows the A.A. Stewart family and their household staff on the front porch of their home. The house, on Washington Avenue, later served as the first hospital in Titusville. (Courtesy of the Brevard County Historical Commission.)

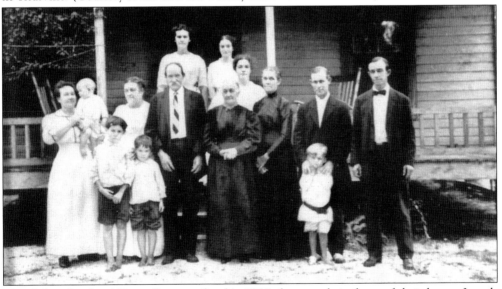

The Osban family of Titusville poses for this 1890 photograph in front of their home. Joseph Wheeler Osban was born in 1842 in South Carolina. After serving in the Confederate Army, he moved to the Titusville area in 1887 with his wife Margaret and their seven children. Osban became a charter member of the First Baptist Church of Titusville in 1889. Shown here, from left to right, are (front row) Annie Osban Stone holding son Jake, Mel Osban Carlile and sons David Nat and Andrew O., Joseph Osban and wife Margaret, Diane Kirby Armfield, Basil W. "Bood" Osban and son Buster, and John "Chap" Osban; (back row) Bertie Peacock Osban, Margaret Carlile Raynor, and Irene Carlile Hall. (Courtesy of the Brevard County Historical Commission.)

A.L. Stewart's daughter Francis posed for this photograph in the 1890s. Francis attended Titusville School with her sisters Kate and Zandie. All three girls continued their education at St. Joseph's Academy in St. Augustine. Francis became ill and died as a young woman. (Courtesy of the Brevard County Historical Commission.)

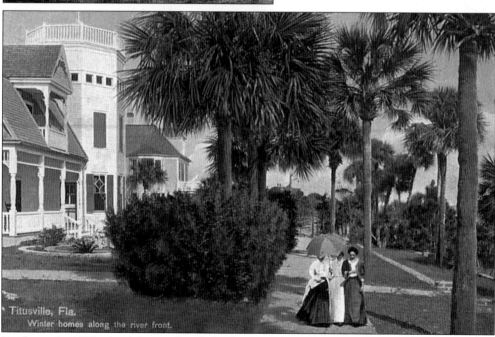

Titusville, Fla.
Winter homes along the river front.

By the early 1900s, large homes lined the bank of the Indian River. Some wealthy families would winter in Titusville while maintaining another residence "up North." This postcard was made in Germany. (Courtesy of the Hugh C. Leighton Co.)

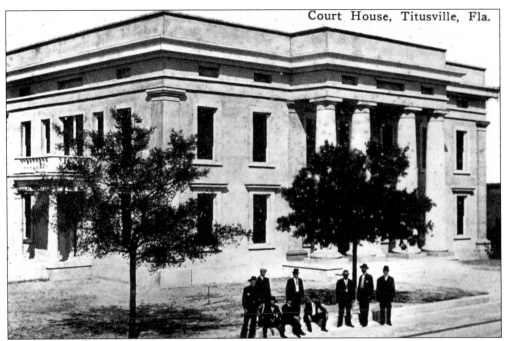

The Brevard County Courthouse was built in Titusville in 1912 on land that was donated by Henry Titus and his wife. This photograph was taken about 1918. The historic courthouse is still in use today. (Courtesy of Florida State Archives.)

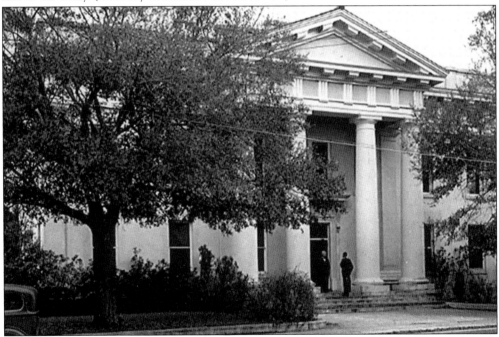

This early 20th-century photograph indicates that shortly after its construction, the exterior of the Brevard County Courthouse was more elaborately decorated. Alternating triglyphs and metopes were added to the frieze above the columns and a triangular pediment was placed on top. (Courtesy of the North Brevard Historical Museum.)

This photograph of Fred Cuyler was taken about 1900. The Cuyler family was one of the first to come to Mims in the 1860s. Today, a park bearing the Cuyler family name provides residents of Mims with a playground, a baseball diamond, and a covered picnic area. (Courtesy of the Brevard County Historical Commission.)

Members of the Campbell family were also early residents of Mims. This photograph from about 1940 shows Katheryn Campbell (left) and Louise Cuyler (right) in Mims. (Courtesy of the Brevard County Historical Commission.)

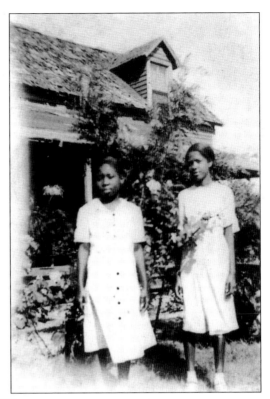

George J. Ohi posed for this photograph in 1913 in Titusville. Civilian Draft Registration Cards for World War I list Japanese citizen Eddie Minora Ohi, born October 25, 1875, as a resident of Brevard County. George and Eddie were probably related. (Courtesy of Florida State Archives.)

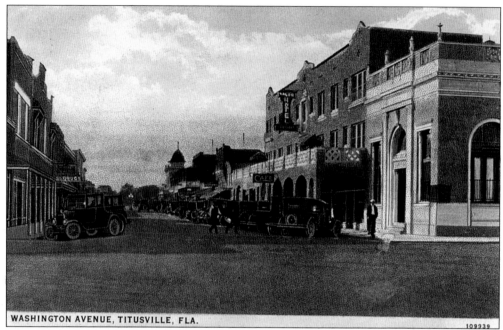

WASHINGTON AVENUE, TITUSVILLE, FLA.

Automobiles line the street in front of some buildings that still stand on Washington Avenue. By 1924 the Titusville Chamber of Commerce was founded to support local businesses. Today, the North Brevard Historical Museum is located on the left corner. (Courtesy of Florida State Archives.)

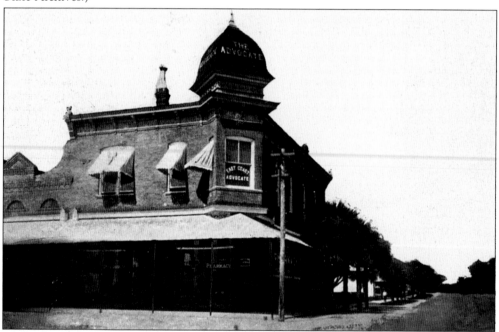

This photograph of the corner of Washington Avenue and Julia Street was taken in the 1920s. The building housed the offices of the *East Coast Advocate* newspaper. Today, the weekly *Star Advocate* newspaper (a subsidiary of *Florida Today*) serves Titusville and Mims. (Courtesy of Florida State Archives.)

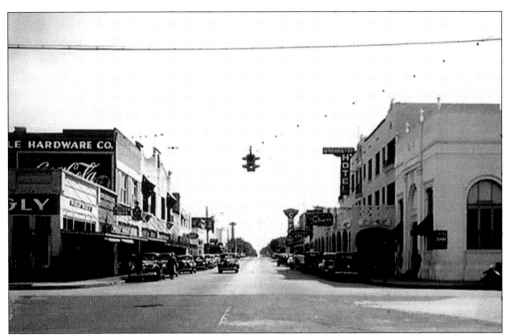

This is another view of Washington Avenue looking south from Main Street. In the 1930s, a Piggly Wiggly grocery store and the Titusville Hardware Store were on the left side of the street, and the Washington Hotel was on the right. (Courtesy of the North Brevard Historical Museum.)

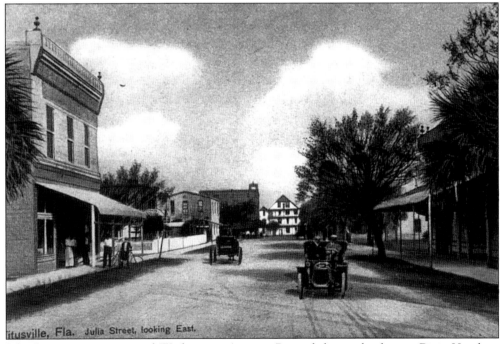

Julia Street runs east toward Washington Avenue. Beyond that is the famous Dixie Hotel on the Indian River. Today, the Emma Parrish Theater is on the right side of the street. (Courtesy of the Brevard County Historical Commission.)

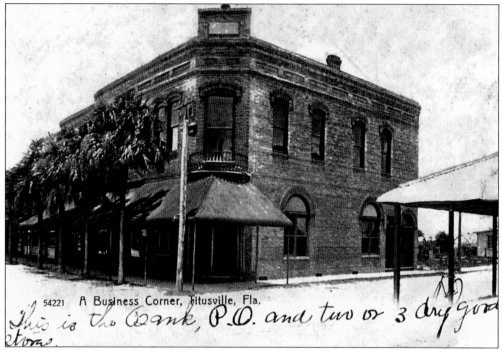

54221 A Business Corner, Titusville, Fla.

This is the Bank, P.O. and two or 3 dry good stores.

The Indian River State Bank was on the northeast corner of Washington Avenue and Julia Street. The bank was founded in 1888. The awning on the right is in front of the Brady Grocery Store. (Courtesy of Florida State Archives.)

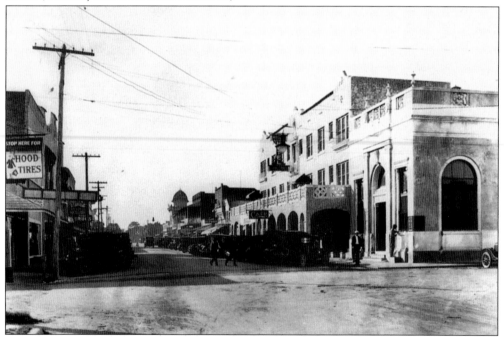

Early in the 20th century, Hood Tires was located across the street from the Washington Hotel. From this angle the distinctive top of the *East Coast Advocate* building can be seen down the street on the right. (Courtesy of the Brevard County Historical Commission.)

The First Baptist Church of Titusville was built in 1892 on Palm Avenue. Farther north on the corner of Palm Avenue and Main Street, the Titusville First Methodist Church was established in 1875. (Courtesy of Florida State Archives.)

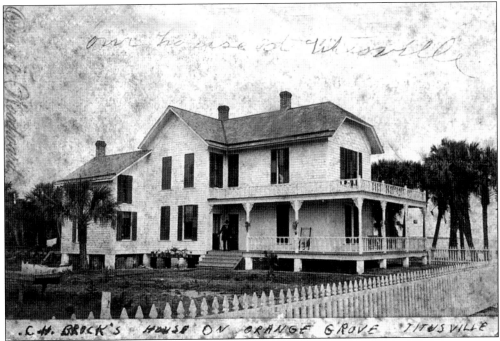

Capt. Charles H. Brock stands on the porch of his home in Titusville. The home was on an orange grove. In 1881, there were more than 200 orange groves along the Indian River. Local farmers also grew pineapples, sugar cane, and vegetables. (Courtesy of Florida State Archives.)

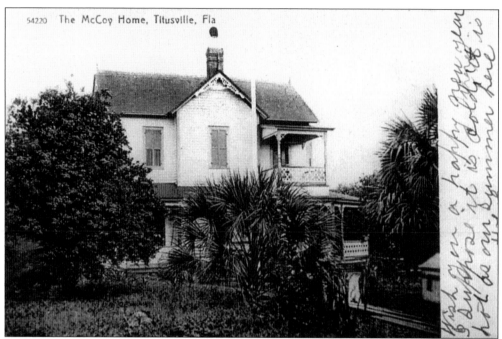

The McCoy home in Titusville was a warm winter residence, as the note on the right of the photograph suggests. (Courtesy of the Brevard County Historical Commission.)

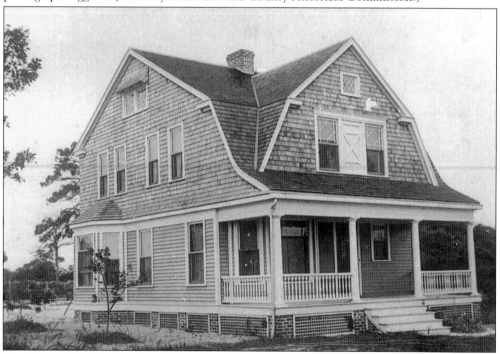

The George Brockett home on Indian River Avenue still stands in Titusville's historic district. The Brockett family co-owned a citrus packing house in Mims with the Nole and Parrish families in the late 1800s. It was purchased by the Mims Citrus Growers Association in 1928. (Courtesy of the Brevard County Historical Commission.)

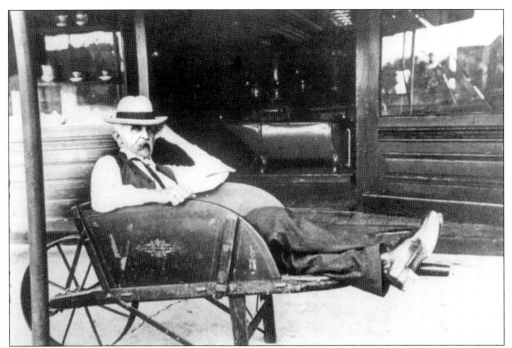

Capt. James Pritchard is shown here sitting in front of his Titusville hardware store in 1920. Pritchard was a successful businessman. In 1888 he established the Indian River State Bank, naming himself president. In addition to his careers as banker and merchant, Pritchard also built the city's first electric light plant. (Courtesy of the Brevard County Historical Commission.)

Not all residents of Titusville lived in large homes on the Indian River. This photograph from the early 1920s shows the Thatcher family home. The sign nailed to the tree says: "Old Furniture Made As Good As New. All Work Guaranteed." (Courtesy of the Alma Clyde Field Library of Florida History.)

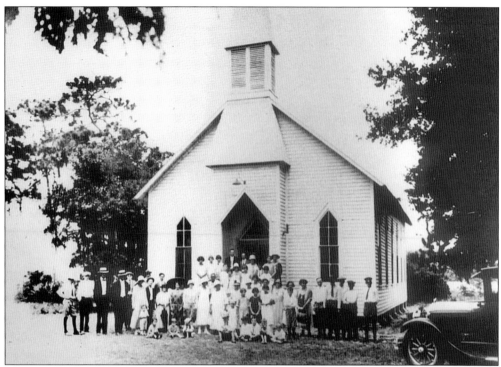

The Mims Methodist Episcopal Church was built in 1889. The congregation gathers outside for this 1920s photograph. (Courtesy of the Brevard County Historical Commission)

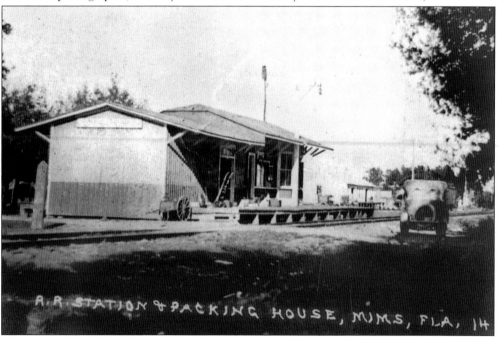

The Mims Railroad Station and Packing House allowed fresh citrus to be shipped to northern states in the early 1900s. Celery and sugar cane were also successfully grown in Mims. (Courtesy of the Brevard County Historical Commission.)

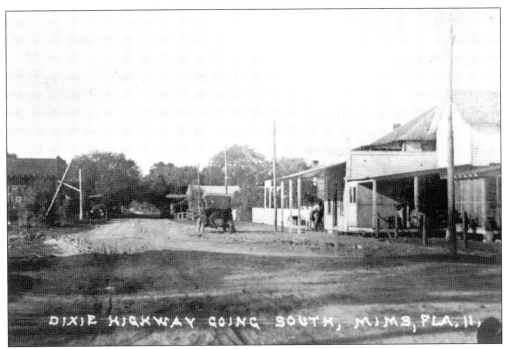

DIXIE HIGHWAY GOING SOUTH, MIMS, FLA. 11.

Mims was growing in the early 1900s, but the stock market crash of 1929 forced many winter residents to abandon homes and businesses. Consequently, the city lost its charter. This photograph shows the Dixie Highway going south in Mims. (Courtesy of the Brevard County Historical Commission.)

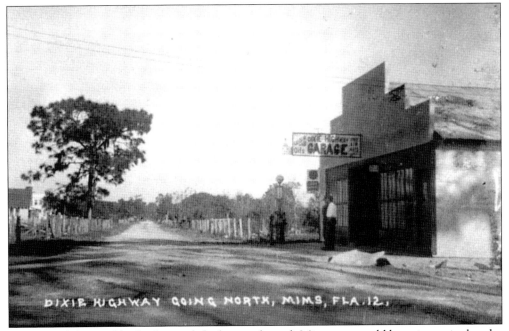

DIXIE HIGHWAY GOING NORTH, MIMS, FLA. 12.

If your Model T Ford broke down while driving through Mims, you could have it repaired at the Dixie Highway Garage. This is a view of the Dixie Highway going north in Mims. (Courtesy of the Brevard County Historical Commission.)

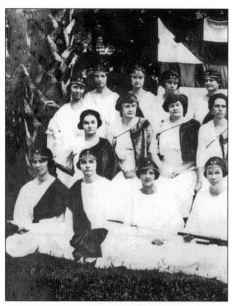

This 1920 photograph shows two unidentified women with a child in Mims. In 1920, Mims was a popular destination for families who wanted to escape cold winters in northern states. The availability of automobiles made travel to the area much easier. (Courtesy of the Brevard County Historical Commission.)

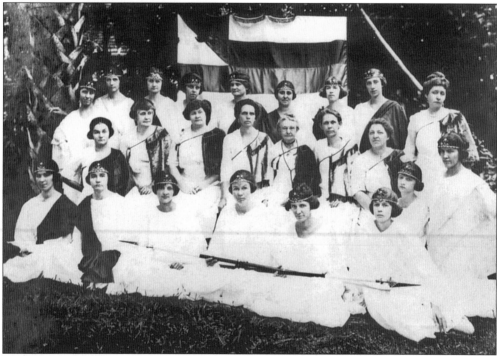

The Pythian Sisters Titusville Temple No. 22 was founded in 1910. The Pythian Sisters did important charitable work during the 20th century. Shown here in 1920, from left to right, are (front row) Mrs. Tom DeCoursey, Irene Carlile, Mrs. R. Love, Jettie Carlile, Belle Mandaville, and Dorothy Osban; (middle row) Maggie Carlile, Mrs. C.J. Denham, Mrs. L. Patrick, Mrs. Walter Giles, Mary Seriminger, Mrs. J.T. McGuire, Mrs. Frank Campbell, Kate Thompson, and Agnes Rogers; (back row) Helen Michel, Laura Darden, Flora Thompson, Bessie Giles, Sallie Thompson, Mrs. Charles Mack, Fay Thompson, Mrs. C.J. Enright, and Mrs. D.B. Pritchard. (Courtesy of the Brevard County Historical Commission.)

Looking east from Washington Avenue, Main Street in Titusville is blocked off for a parade on April 2, 1927. (Courtesy of the North Brevard Historical Museum.)

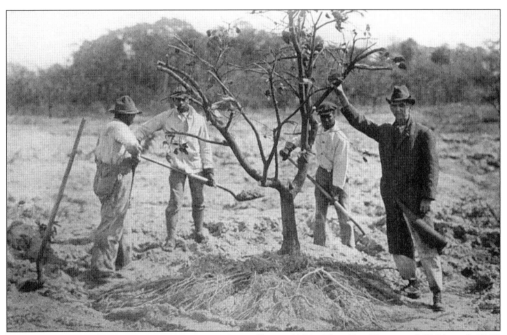

These men are planting a citrus tree in Titusville in 1923. The Big Freeze of 1894 and 1895 temporarily crippled the citrus industry in Central Florida, but by the 1920s it was again an important part of the local economy. (Courtesy of the Brevard County Historical Commission.)

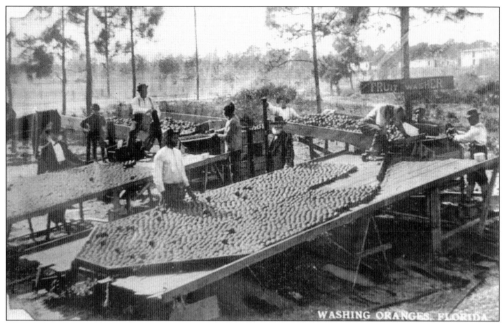

Workers in Titusville wash oranges before shipping them in 1900, just five years after the Big Freeze of 1894 and 1895 almost wiped out the local groves. (Courtesy of the Brevard County Historical Commission.)

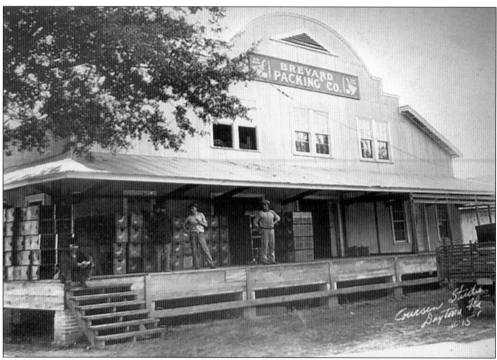

North Brevard County had the largest orange grove in Florida by 1867. The Brevard Packing Company, shown here in 1926, was located in Mims on Route 46. The Blue Goose brand came out of this packing plant. (Courtesy of the North Brevard Historical Museum.)

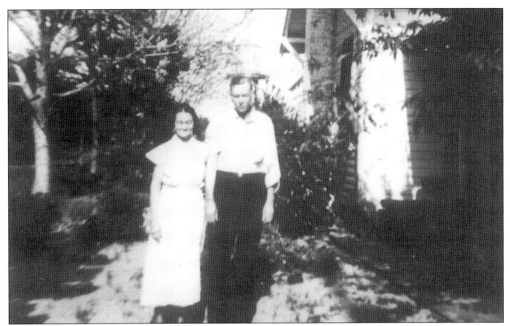

Ida Mae Green and Ames Green stand outside of their home in Mims in 1930. Even after Mims lost its city charter following the stock market crash of 1929, some families decided to remain in the town. (Courtesy of the Brevard County Historical Commission.)

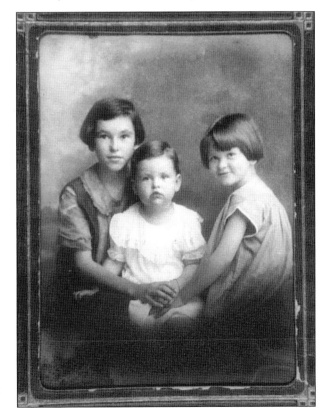

In this photograph, from left to right, are Eleanor, Virginia, and Eva Green, of Mims, who posed in 1930. (Courtesy of the Brevard County Historical Commission.)

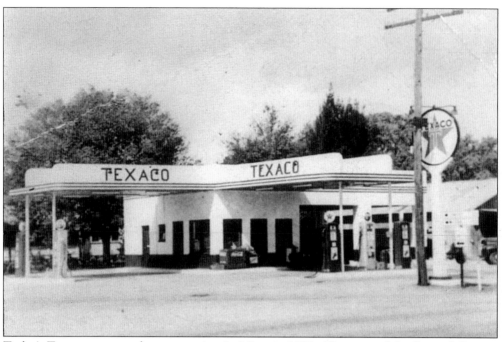

Taylor's Texaco was a modern gas station in Mims in 1930. (Courtesy of the Brevard County Historical Commission.)

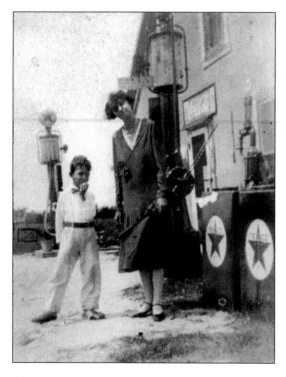

Maymie Taylor Dunn (right) and son Taylor (left), shown here in 1930, stand by the Texaco gas pumps operated by Mr. Dunn in Mims. (Courtesy of the Brevard County Historical Commission.)

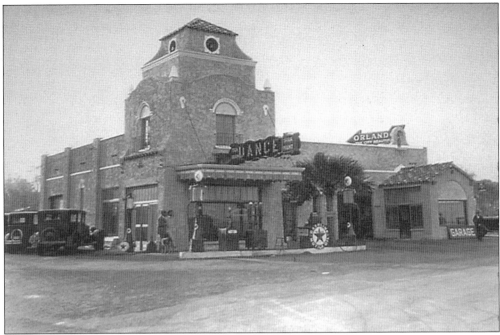

Frank G. Clark developed Clark's Corner in 1927 at the intersection of Dixie Highway and State Road 50. The gas station and garage also housed a dance hall. The arrow on top of the building points toward "Orlando, The City Beautiful." (Courtesy of the North Brevard Historical Museum.)

This early 20th-century postcard offers a "Bird's Eye View" of Titusville from the Dixie Tower. (Courtesy of Florida State Archives.)

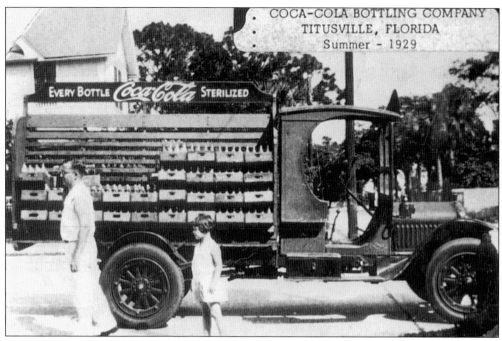

EVERY BOTTLE *Coca-Cola* STERILIZED

Coca-Cola was bottled in Titusville beginning in 1916. Frank Snell was the manager of the Coca-Cola Bottling Company in Titusville in 1929. He is shown here with his five-year-old daughter Waldene. (Courtesy of Florida State Archives.)

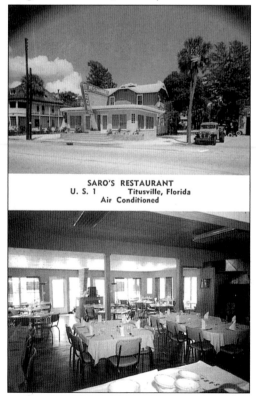

SARO'S RESTAURANT
U. S. 1 Titusville, Florida
Air Conditioned

A. Thomas Saraceno was the proprietor of Saro's Restaurant in downtown Titusville. In the mid-20th century Saro's was "Titusville's newest and most modern restaurant. Air conditioned for your comfort." (Courtesy of Bohannon's Studio and Camera Shop.)

The Women's Club of Titusville met in this building in 1952. Today, a variety of non-profit and charitable organizations operate in Titusville. (Courtesy of Florida State Archives.)

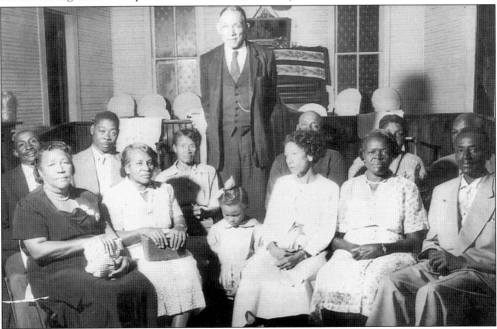

The Rev. James A. Massey stands among members of the former St. James Baptist Church of Mims in the early 1960s. For 31 years, Reverend Massey was pastor of both St. James and Greater St. James Missionary Baptist Church. Seated from left to right are (front row) Daisy Harris, Ada Seigler, Florine Hatfield, Mother Mamie King Bell, and Deacon Eugene Abrams; (back row) Deacon Ezekiel Grant Jr., Deacon Fuller S. Seigler, Minnie Grant, Melvin Claire, Lisa Shelton, and Deacon H.J. Strickland. The little girl in the center is Martha Jean Stroman Allen. (Courtesy of the Brevard County Historical Commission.)

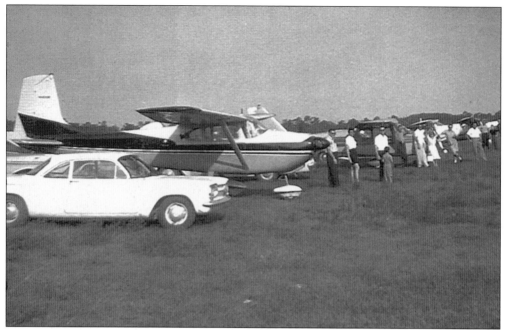

Small airplane enthusiasts gathered in Titusville in the 1960s. Today, several small airports operate in the Titusville area, including Arthur Dunn Air Park Airport, Space Center Executive Airport, and Space Coast Regional Airport. (Courtesy of the North Brevard Historical Museum.)

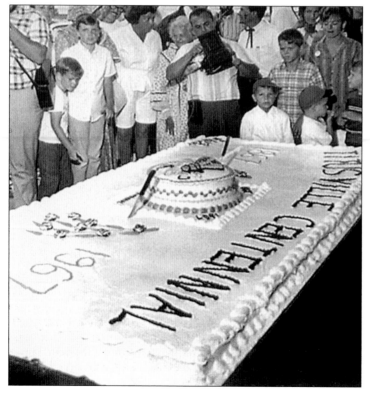

Titusville celebrated its centennial in 1967. The town hosted a parade, historical re-enactments, and other special events. (Courtesy of the North Brevard Historical Museum.)

These unidentified children dress in period costumes to help recognize the first 100 years of Titusville's existence. (Courtesy of the North Brevard Historical Museum.)

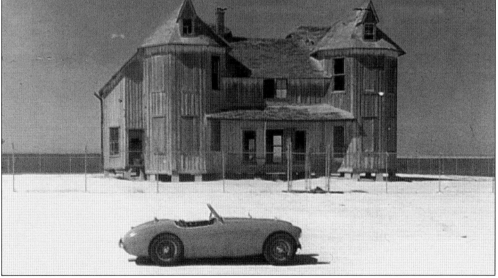

The Dummitt House, shown here in 1965, was built in 1872 using timbers from salvaged shipwrecks and heart pine. The home was originally located in the oldest orange groves in Florida, established by Douglas D. Dummitt in 1807. The federal government confiscated Dummitt's groves to build the Kennedy Space Center, and the Dummitt House was relocated to Titusville in 1967. Plans were made to transform the home into a museum, but it burned down before those dreams were realized. (Courtesy of the Alma Clyde Field Library of Florida History.)

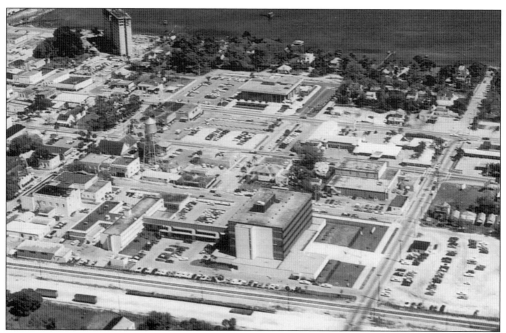

This aerial view of downtown Titusville was photographed in the early 1970s. The large building in the center foreground is the Brevard County Courthouse, built in the mid-1950s to replace the 1912 courthouse. (Courtesy of the Alma Clyde Field Library of Florida History.)

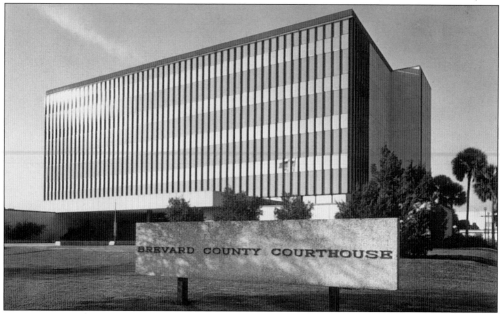

This annex to the Brevard County Courthouse, shown here in 1976, is now called the Brevard County Government Complex North. It was constructed in response to the local population increase that accompanied the initiation of the space program in the mid-20th century. Offices in the building issue passports, marriage licenses, and voter registration cards, and they collect traffic fines and taxes. The property appraiser, public defender, and other government officials also work in this building. (Courtesy of Florida State Archives.)

Three

SCHOOL DAYS

The history of educational institutions in Titusville and Mims parallels the general history of the area. As pioneers came here in the mid-1800s, a man named Tom Johnson offered informal classes in reading, writing, and arithmetic to students of all ages. Johnson, known as "Uncle Tom," held classes in his copper shop at night. When the LaGrange community was established in what would become Titusville and Mims, a log building was constructed in 1869 that served as both the church and the school. A total of 17 students of various ages attended classes taught by Narcissa Feaster. As the population of Titusville and Mims grew in the late 1800s, one-room schoolhouses were built to accommodate different age groups. By the early 1900s, larger, more centralized schools were being constructed.

Through the mid-20th century, racial segregation in educational institutions was the norm in many American towns, particularly in the Southern states, and schools in Titusville and Mims were no exception. In the 1950s, white students attended Titusville Elementary, Mims Elementary, and Titusville High School. African-American students went to the Titusville Negro School, the Mims Negro School, and the Andrew J. Gibson School. Andrew Gibson was born a slave in Georgia in 1830. After moving to Titusville in 1873, Gibson became a respected entrepreneur, operating a desegregated restaurant and working as a jailer, a barber, and a shoe repairman. Gibson also realized the importance of education to all people. As Civil Rights leader Malcolm X once said, "Education is our passport to the future, for tomorrow belongs to the people who prepare for it today."

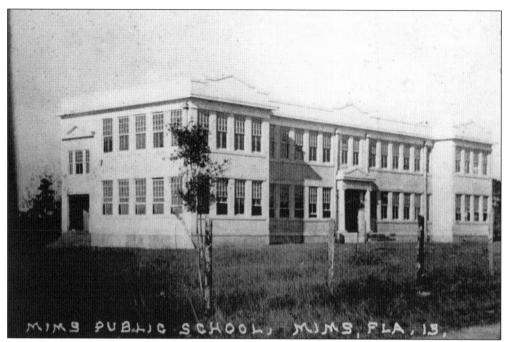

Mims Public School moved into this building in 1917. The concrete structure replaced a one-room schoolhouse that was accidentally burned down. Wild hogs had moved underneath the old schoolhouse, and it was consequently infested with fleas. An attempt to smoke out the fleas became an uncontrolled fire. (Courtesy of the Brevard County Historical Commission.)

These elementary school students attended Mims Public School in 1920. Today, a newer Mims Elementary School stands on the same site as the original 1917 school, while older students attend Astronaut High School or Titusville High School. (Courtesy of the Brevard County Historical Commission.)

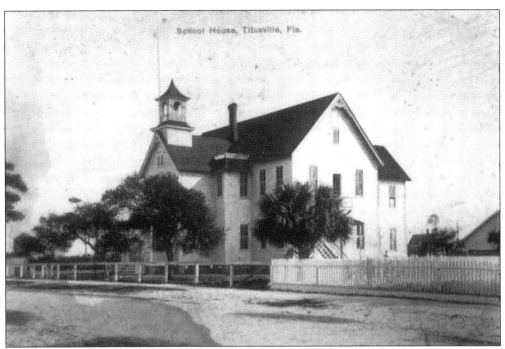

The Titusville School was built in the late 1800s to accommodate grades 1 through 12. This building was replaced in 1917 by a three-story concrete building. (Courtesy of the Brevard County Historical Commission.)

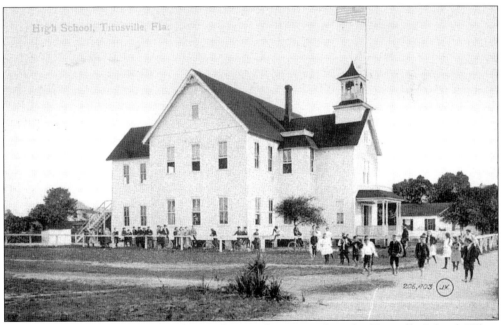

This image from the early 1900s shows white students attending the Titusville School. When the new concrete building was constructed on this Washington Street site, the wooden building seen here was moved to Wager Street and renamed the Titusville Negro School. (Courtesy of Florida State Archives.)

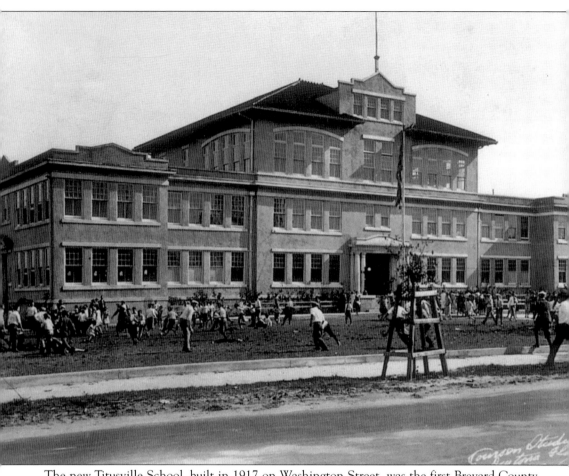

The new Titusville School, built in 1917 on Washington Street, was the first Brevard County School made of concrete. All 12 grades were educated in the school's 20 classrooms. The school had a gymnasium on the third floor, an auditorium, and a cafeteria in the basement. In 1927, a new high school was constructed, and this became Titusville Elementary School. (Courtesy of the Brevard County Historical Commission.)

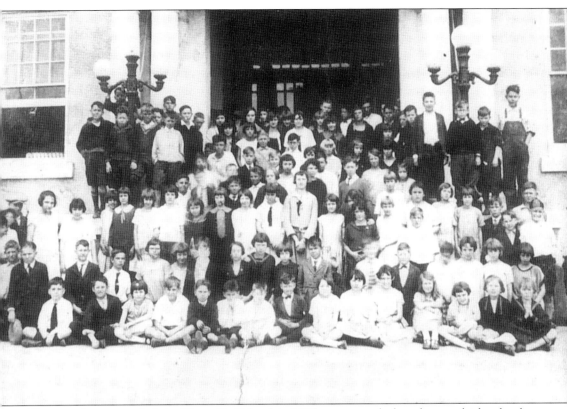

These students attended the Titusville School in 1925, two years before the new high school was built. The students here represent all grades. African-American students attended the Titusville Negro School in supposedly "separate but equal" facilities, as dictated by the U.S. Supreme Court case *Plessy v. Ferguson* in 1896. Schools remained segregated until the Supreme Court declared them "inherently unequal" in 1954 with their decision in the *Brown v. the Board of Education of Topeka* case. (Courtesy of the Brevard County Historical Commission.)

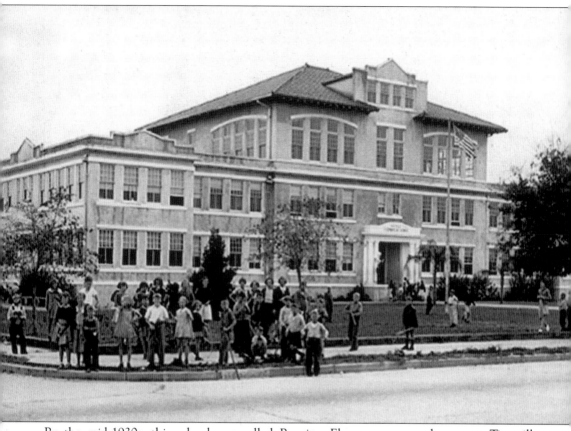

By the mid-1930s, this school was called Bayview Elementary, once known as Titusville Elementary and before that, the Titusville School. The building functioned as Bayview Elementary until 1972, when it was torn down to make room for the new Titusville Courthouse. (Courtesy of the North Brevard Historical Museum.)

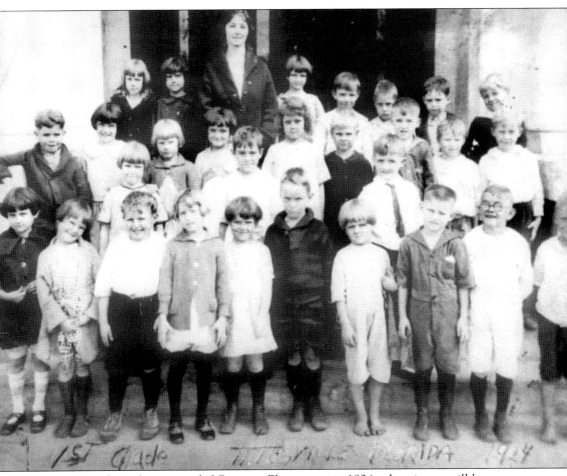

These first grade students attended Bayview Elementary in 1924, when it was still known as the Titusville School and all 12 grades were educated under one roof. As this photograph shows, some of the students came to school barefooted. The boy leaning against the cornerstone in the second row is Lee Day. The Day family were early settlers in the area and charter members of LaGrange Church in 1869. Lee Day lived on Palm Lane in Titusville with his parents William and Mary Day, who ran the County Home in the 1920s and 1930s. Lee and his wife, Evelyn, operated the home in the 1940s and 1950s. (Courtesy of the Brevard County Historical Commission.)

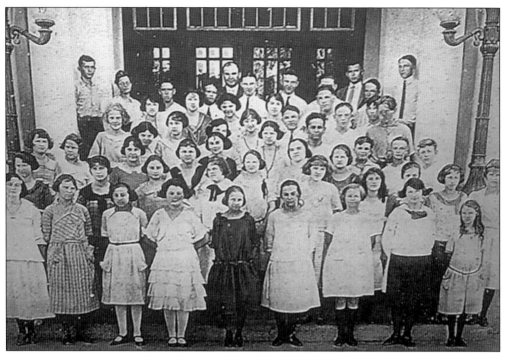

The 1923 graduating class of the Titusville School gathers outside for this photograph. Students beginning high school that same year would graduate from the new Titusville High School. (Courtesy of the North Brevard Historical Museum.)

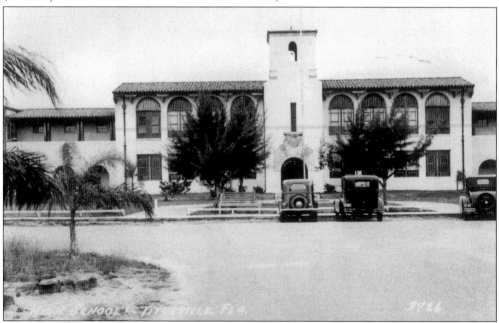

In 1927 Titusville High School was built, and the Titusville School became Titusville Elementary and later Bayview Elementary. The new school was built using the Spanish-style architecture popular in Florida in the 1920s. (Courtesy of the Brevard County Historical Commission.)

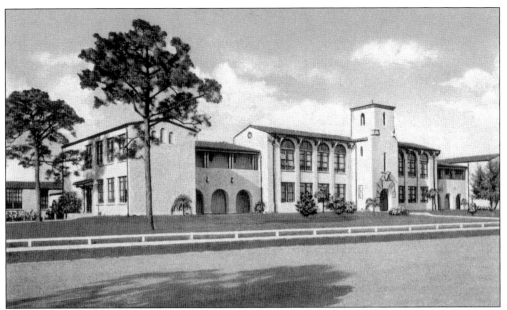

This drawing of Titusville High School offers a more complete view of the school. In 1972, this building was torn down and replaced on the same site with a more modern, but less architecturally interesting, building. (Courtesy of Florida State Archives.)

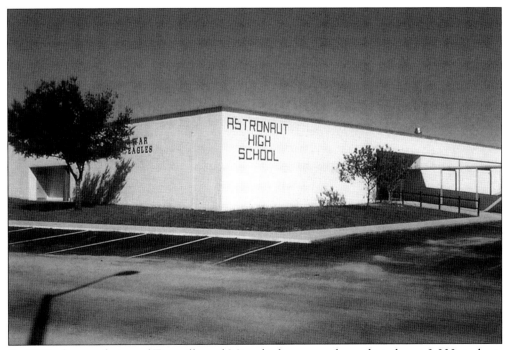

By 1970, the population of Titusville and Mims had grown so large that almost 3,000 students attended Titusville High School. In 1971, Astronaut High School was built to help relieve that burden. (Courtesy of Astronaut High School.)

The Titusville campus of Brevard Community College (BCC) began in a downtown storefront that offered a few continuing education classes in the late 1960s. By 1973, BCC Titusville moved to the Andrew J. Gibson School on Sycamore Street. From 1977 to 1979, BCC Titusville was moved to Whispering Hills Elementary on South Street and then to its current location on U.S. Highway 1. The campus had only one building until 1990, when three additional buildings were constructed. Today, the Titusville campus of Brevard Community College offers a full schedule of undergraduate courses leading to a variety of associate degrees and encourages lifelong learning with stimulating classes. (Courtesy of Brevard Community College.)

Four

ARTS AND CULTURE

From the time that the earliest humans first painted on cave walls and put on costumes to perform ritual dances, the arts have been an integral part of the human experience. Throughout time, the arts and humanities have expressed who we are and what we feel. To look at a painting or listen to a piece of music and understand the historical context in which it was created enriches our present lives. By looking at how communities of people express themselves artistically, we can learn much about how they think and what they believe is important.

The arts also connect us as human beings. The people of Windover carefully wove fabric from plant materials, and today the Space Coast Quilters regularly display their work in Titusville. For more than half a century local audiences have been enjoying performances of classical music played by the Brevard Symphony Orchestra. Theatrical productions at the Emma Parrish Theater bring time-tested plays and musicals to new audiences. Multicultural celebrations encourage tolerance and understanding between people of different races and ethnic backgrounds. Titusville and Mims are never more vibrant and alive than when main streets are closed to traffic so artists can display their work and live music fills the air. The preservation of historic buildings and active celebrations of history provide local residents with a sense of community.

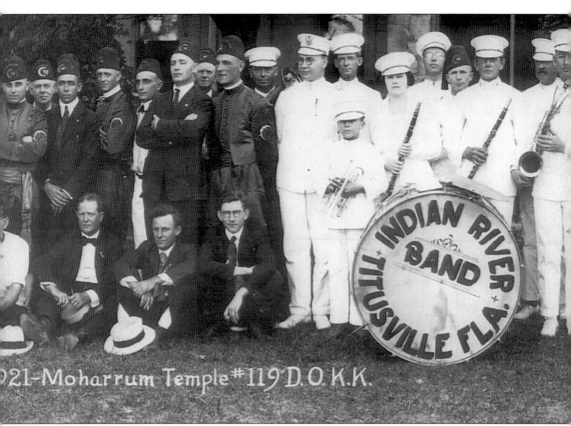

The Indian River Band of Titusville was formed in 1889, making it one of the oldest performing arts organizations in Central Florida. As this photograph indicates, men, women, and children all played in the band. The group was asked to play for many social functions in the community. Shown here in 1921, the band is posing with members of a local civic club. (Courtesy of the Brevard County Historical Commission.)

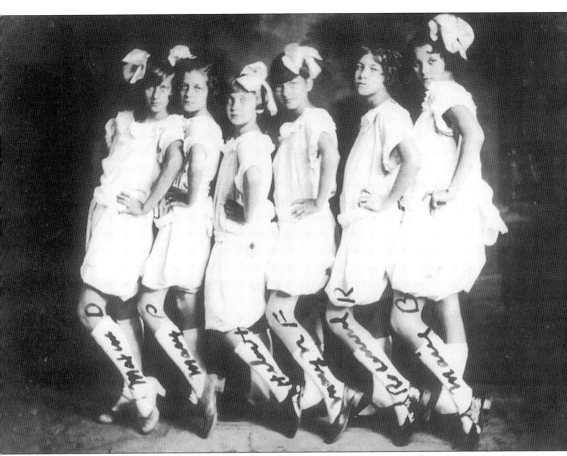

This talented group of young women is performing a song and dance to the George Olsen, Eddie Kilfeather, and Fran Frey song "You Need Someone to Love." The performance was given in the Titusville School auditorium in the 1920s. Pictured from left to right are Maxine Darden, Mary Pritchard, Helen Hunt, Mary Norris Froscher, Rosemond Rodgers, and Marie Boye. (Courtesy of the Brevard County Historical Commission.)

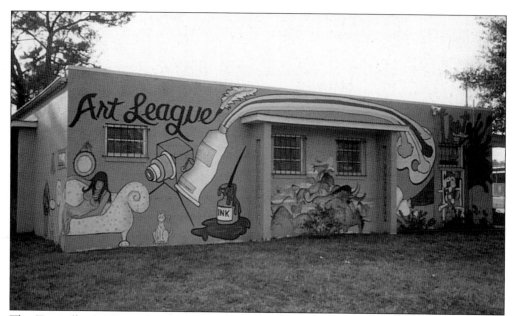

The Titusville Art League was incorporated in 1962. Some 15 students inspired by evening adult art classes they were taking at Titusville High School formed the organization. Today the Art League has more than 140 members and offers classes in stained glass, pottery, painting, and watercolor for children and adults. (Courtesy of the Titusville Art League.)

The pottery building of the Titusville Art League provides workspace for local artists who display their work at the many outdoor art festivals in the area. The Art League also operates a gallery in the Searstown Mall that sells locally created paintings, photography, sculpture, stained glass, jewelry, clothing, and ceramics. (Courtesy of the Titusville Art League.)

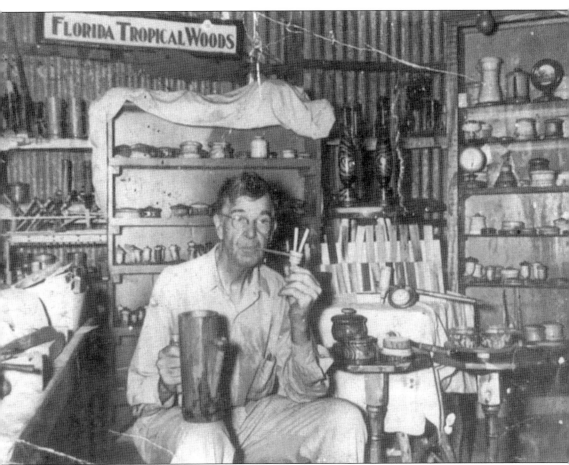

L.E. Hudson was a very talented woodworker who specialized in vessel structures and furniture. In the early to mid-20th century, Hudson operated a shop called Florida Tropical Woods. The shop was located behind Pirtle's Central Garage in Titusville. In 1934, the Florida World's Fair Commission sponsored a display of Hudson's work at the "World of Progress" exhibition in Chicago. (Courtesy of the Brevard County Historical Commission.)

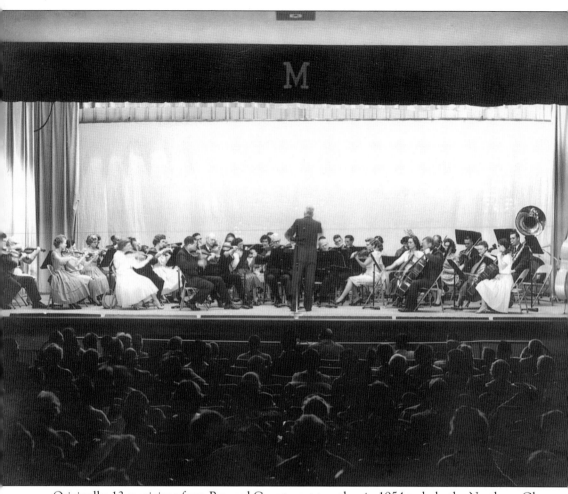

Originally, 13 musicians from Brevard County got together in 1954 to help the Northrop Glee Club stage the Gilbert and Sullivan operetta *The Mikado*. The show, a satire of Japanese culture best remembered for the song "Three Little Maids From School Are We," was so much fun that the musicians decided to stay together under the name Brevard Light Concert Orchestra. As the group expanded, the name was soon changed to the Brevard Symphony Orchestra (BSO). The BSO plays concerts of classical music throughout Brevard County, including performances in Titusville. The orchestra is shown here in 1965 under the direction of original conductor Frederick Jaehne. (Courtesy of the Brevard Symphony Orchestra.)

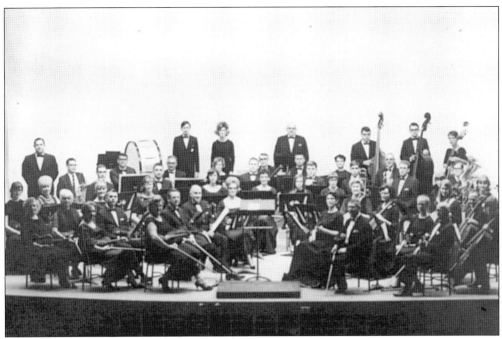

Under the direction of Joseph Kreines, from 1965 to 1976, the orchestra gradually evolved from a volunteer group to a professional organization. This photograph of the BSO is from 1967. (Courtesy of the Brevard Symphony Orchestra.)

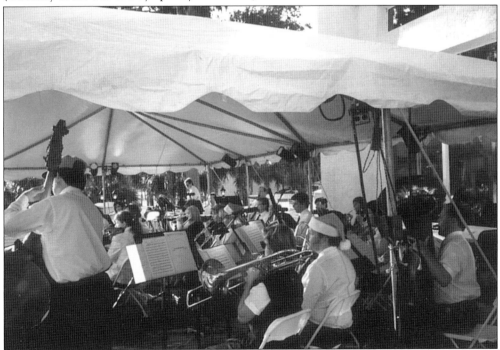

In 1995, Christopher Confessore became music director and principal conductor of the Brevard Symphony Orchestra. In the late 1990s, the BSO played an annual Holiday Concert at La Cita Golf Course and Country Club in Titusville. (Courtesy of the Brevard Symphony Orchestra.)

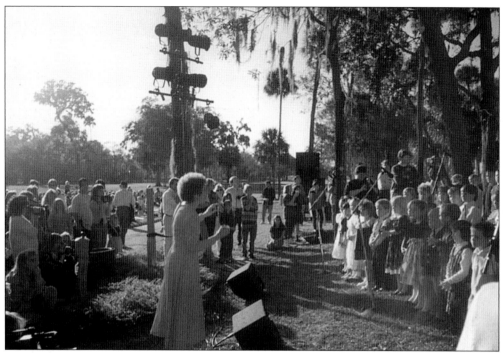

Sheila King conducts elementary school students from Titusville in a concert at La Cita Golf Course and Country Club. (Courtesy of the Brevard Symphony Orchestra.)

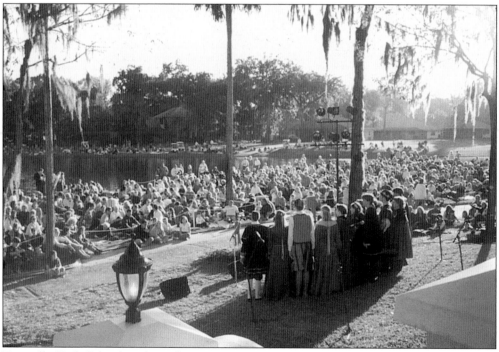

Titusville High School students dress in Renaissance-era costumes and sing madrigals for the annual Holiday Concert at La Cita. (Courtesy of the Brevard Symphony Orchestra.)

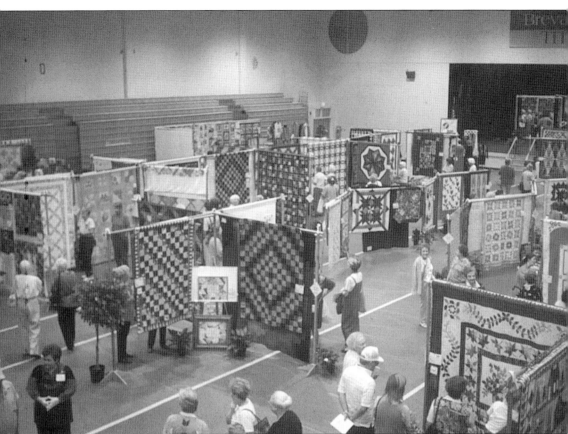

The Space Coast Quilters meet the third Wednesday of every month at the First Baptist Church of Titusville. Their intricately stitched and colorful creations are truly functional works of art. In addition to being comfortable and beautiful, quilts played an important role in American history. During the Civil War, African-American and white abolitionist quilters would sew specific patterns into their quilts and hang them on porch rails or out windows to guide runaway slaves navigating the Underground Railroad. Every other year, the Space Coast Quilters host the "Quilting From the Heart" exhibition on the Titusville campus of Brevard Community College. (Courtesy of Brevard Community College.)

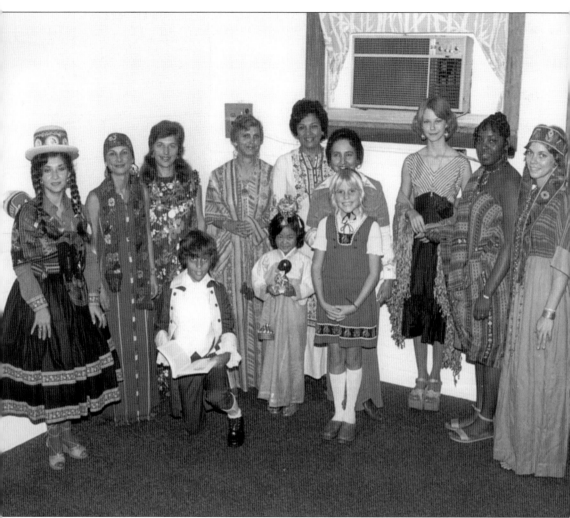

While the Brevard Community College Titusville campus was located in the Andrew J. Gibson School, faculty member Samiah Abdel-Al (fifth from left in back) promoted multi-cultural awareness with programs like this one from 1974 that celebrated ethnic diversity. Today, BCC Titusville hosts events such as the Moore Heritage Festival of the Arts and Humanities and other cultural programs and concerts. (Courtesy of Brevard Community College.)

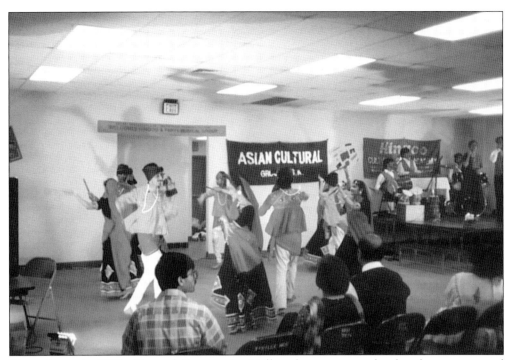

Since the early 1970s, Brevard Community College has encouraged cultural awareness and understanding in the Titusville area by promoting events such as this Asian Festival held in 1994. (Courtesy of Brevard Community College.)

This group of men donned costumes to participate in the Titusville centennial celebration in 1967. Historical re-enactments and other special events were part of the festivities. (Courtesy of the North Brevard Historical Museum.)

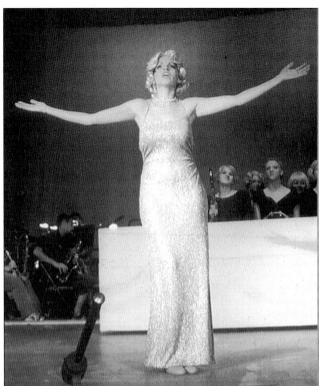

The Titusville Playhouse, Inc., began in 1963 under the name the Little Theater, performing in the city garage, clubhouses, and just about any other venue they could find. Oli Crytzer belts out a song as the title role in *Sugar*, a musical adaptation of the 1959 film *Some Like It Hot*. (Courtesy of the Titusville Playhouse, Inc.)

Built in 1905 as the Magnolia Theater, this building would be the future home of the Titusville Playhouse. This is how the building looked in the 1970s when it was being used as a movie theater. (Courtesy of the Titusville Playhouse, Inc.)

In the early 1980s, extensive renovations transformed the old Magnolia Theater into the Emma Parrish Theater, home of the Titusville Playhouse, Inc. Now the cultural heart of Titusville, this theater has also been used as a saloon, a pool hall, a silent movie house, and apartments. Today the Titusville Playhouse presents six plays and musicals per year in the Emma Parrish Theater, as well as more experimental plays in Emma's Attic. The theater also offers the Children's Theater Arts program for grades 1 through 5 and the Rising Stars Theater program for grades 6 through 12. (Courtesy of the Titusville Playhouse, Inc.)

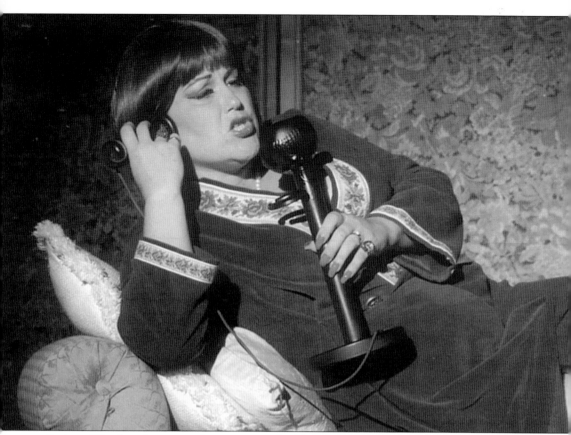

Barbara Woodward is a popular actress at the Emma Parrish Theater. She has had featured roles in Titusville Playhouse productions of *Cat on a Hot Tin Roof*, *Mame*, *Teahouse of the August Moon*, *The King and I*, and *Oklahoma*. Here Woodward is playing Tara Boneaparte, the unscrupulous business manager in the 1920s melodrama *Wynn Fairly, Champeen Rassler*. (Courtesy of the Titusville Playhouse, Inc.)

Five

SPORTS AND LEISURE

Recreational activities in Titusville and Mims have not really changed all that much over the past century. People still enjoy going to the beach, fishing, and playing tennis as they did 100 years ago. Playing and watching team sports has been a favorite pastime of local residents since such activities were first organized in the early 20th century. Golf remains a passion for many people here, as it was when the first golf course in the area was created in the 1920s. Today there are many public, private, and semi-private golf courses to choose from in the immediate vicinity of Titusville and Mims.

The importance of sports and recreational activities locally is evident when reading the weekly newspaper. The Star Advocate (published by Florida Today newspaper to serve Titusville, Mims, and Scottsmoor) has two sections. The main section covers local news and community activities. This section of the paper also has locally written editorials and the popular "Mullet Wrapper" column, written by regional historian Bob Hudson. The other section of the weekly newspaper is entirely devoted to local sports. High school athletes are covered with the same enthusiasm as national sports figures.

Sports and leisure activities allow members of the community to come together and share a common experience, promoting a sense of unity. This is as true in Titusville and Mims today as it was 100 years ago.

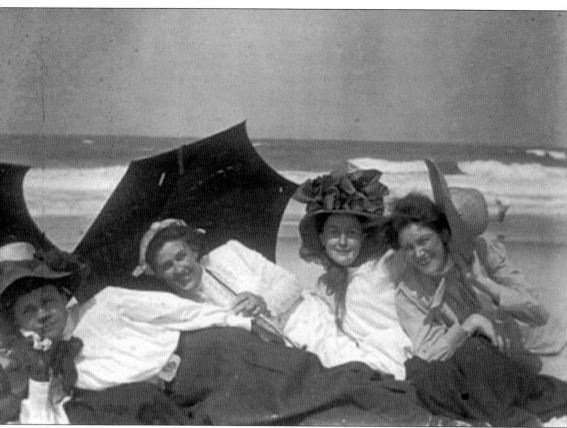

These four unidentified women from Titusville are enjoying a leisurely day at Titusville Beach in 1915. Titusville Beach was located across the Indian River from Titusville on the northeastern edge of Merritt Island, the barrier island that separates Titusville from the Atlantic Ocean. After the Cape Canaveral Air Force Station and the Kennedy Space Center were built on the northern end of Merritt Island, the federal government eventually claimed the land that was Titusville Beach. Today, these four women would be looking at the space shuttle launch pads. (Courtesy of the Brevard County Historical Commission.)

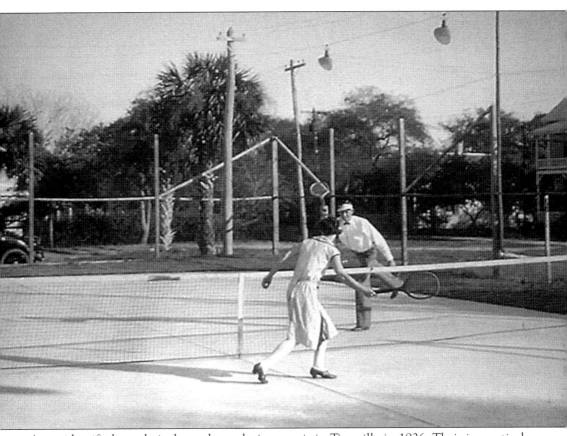

An unidentified couple is shown here playing tennis in Titusville in 1926. Their impractical sports clothing must have made the game very difficult. The electric light fixtures visible in the top right of the photograph indicate that illuminated evening games were possible. (Courtesy of the North Brevard Historical Museum.)

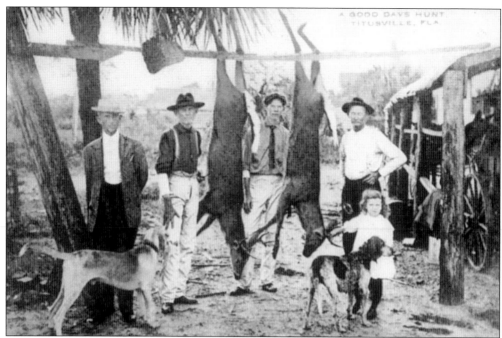

This photograph from about 1900 shows a party enjoying "A Good Day's Hunt" in Titusville. They are, from left to right, L.A. Brady, P.J. Hall, his son Frank Hall, Lloyd Peacock, and unidentified. Wild deer were plentiful in North Brevard County in the last century and can still be seen today. (Courtesy of the Brevard County Historical Commission.)

Wild hogs were also hunted in the early days of Titusville and Mims. They, too, can still be seen along rural roads in North Brevard County. Today, hunting is considered a sport, but wild animals were once an important source of food for local pioneers. (Courtesy of the Brevard Museum of History and Natural Science.)

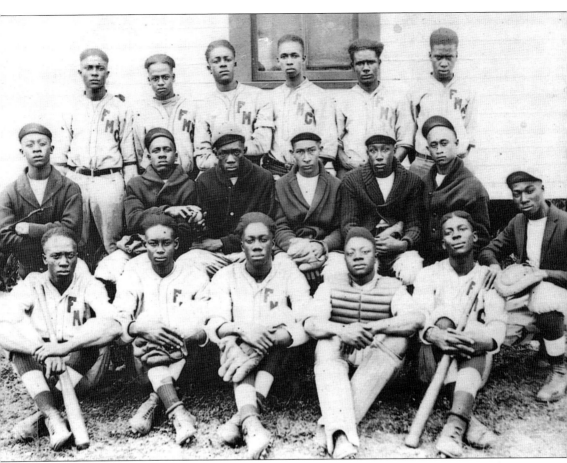

This African-American baseball team was photographed in the early 1920s. Harry T. Moore (back row, fourth from left) would become the most famous resident of Mims as an educator and Civil Rights activist. Moore was hired as principal of Titusville Negro School in 1927. During the same time period, the Titusville Terriers baseball team played for Titusville High School. Today, Titusville High and other local schools also have programs in football, basketball, cross country, track, softball, volleyball, wrestling, golf, soccer, swimming and diving, and tennis. (Courtesy of the Moore Cultural Complex.)

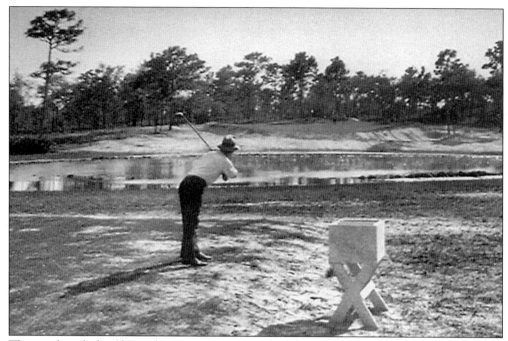

This unidentified golfer is playing on the Whispering Hills Golf Course in Titusville in 1926. He is 120 yards from the 15th hole. Golf is extremely popular in Titusville and Mims. (Courtesy of the North Brevard Historical Museum.)

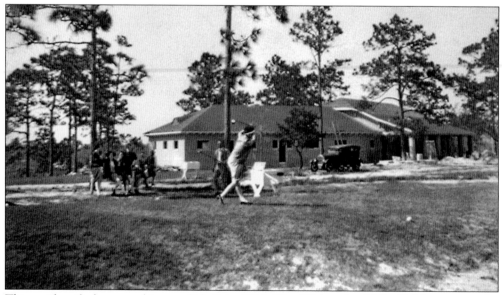

This unidentified woman hits a golf ball in 1926. The Whispering Hills Clubhouse is under construction behind her. (Courtesy of the North Brevard Historical Museum.)

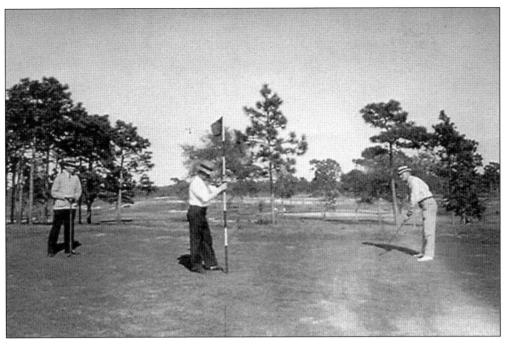

These unidentified men are on the ninth green at Whispering Hills. Other golf courses in the immediate Titusville and Mims area include Sherwood Golf Club, Walkabout Golf Club, Willow Lakes Golf Resort, Space Coast National Golf Club, La Cita Country Club, The Great Outdoors, and Royal Oak Golf Club. (Courtesy of the North Brevard Historical Museum.)

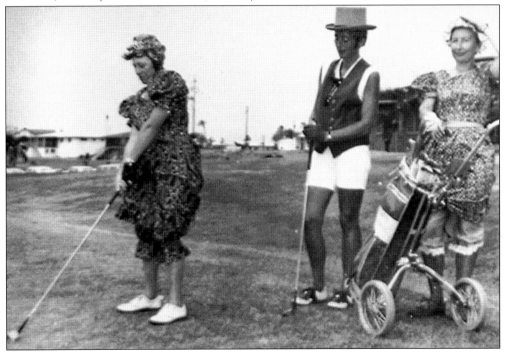

These unidentified women are playing a golf tournament in costume as part of the Titusville centennial celebration in 1967. (Courtesy of the North Brevard Historical Museum.)

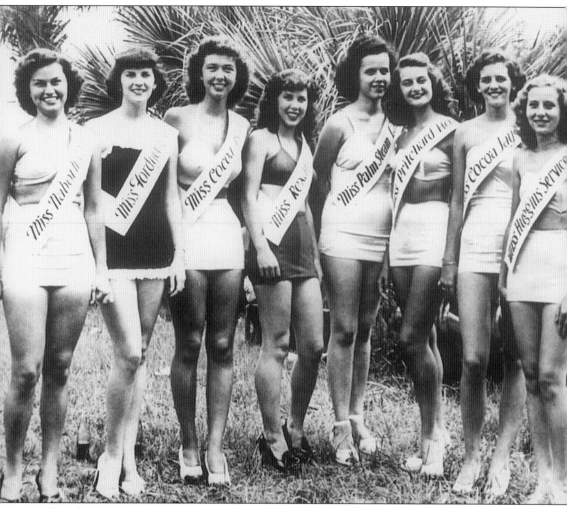

These lovely young women are participants in the "Bathing Beauty Contest" held as part of the 1940 Fourth of July festivities in Titusville. From the early days of the town to the present, the Fourth of July is recognized as an important holiday to celebrate in Titusville. In addition to beauty contests, festivities of the past have included parades and, of course, impressive fireworks displays. From the public dock in Titusville, several professional fireworks displays can be seen. (Courtesy of the Brevard County Historical Commission.)

These unidentified young people are conversing at the Canaveral National Seashore near Titusville in the 1960s. The beaches near Titusville and Mims have attracted vacationers and residents for more than a century. (Courtesy of Florida State Archives.)

This unidentified family is fishing at Fox Lake Park in Titusville in 1975. Fox Lake Park is the site of many large community events. A paved road winds through the park, which is more than 30 acres. A fishing dock and boat ramp provides access to Fox Lake and South Lake. There are sand volleyball courts and many picnic pavilions with barbeque grills. A large pavilion with seating for 1,000 people also has a kitchen and stage available for public use. (Courtesy of Florida State Archives.)

Six

BACK TO NATURE

Florida's lush plant life, unique wildlife, and beautiful beaches have attracted people here for centuries. Postcards from the late 1800s and early 1900s tempt potential residents and visitors with visions of warm winters and breathtaking sunrises over the ocean. Unfortunately, unprecedented growth has threatened many of the area's indigenous animals and strained some natural resources. An increase in awareness about environmental issues in recent decades has inspired efforts to combat those problems.

Titusville and Mims are virtually surrounded by the natural beauty that is the "real" Florida. The Canaveral National Seashore, the Merritt Island National Wildlife Refuge, and the Tosohatchee State Reserve are all environmentally protected lands that the public can enjoy. Titusville's Enchanted Forest Sanctuary is one of the largest remaining tracts of coastal hardwood forest in the area. There are numerous opportunities available to experience nature through walks, airboat rides, and guided tours.

As urban sprawl envelops much of Central Florida and is pushing east from Orlando toward Titusville and Mims, local residents can be thankful that protected lands along the St. John's River help form a barrier between them and over-development. It may be these protected lands that will allow Titusville and Mims to retain their unique sense of identity as a community and not be swallowed up by unrestrained growth.

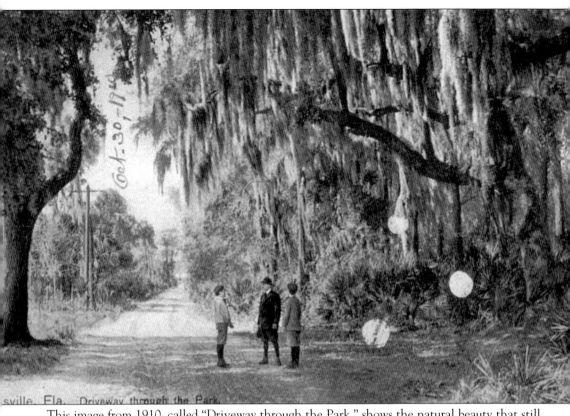

sville, Fla. Driveway through the Park.

This image from 1910, called "Driveway through the Park," shows the natural beauty that still exists in and around Titusville and Mims. The large trees in the foreground have Spanish moss hanging from their branches, and palm and palmetto trees are growing wild along the dirt road. This is from a Hugh C. Leighton postcard. (Courtesy of Florida State Archives.)

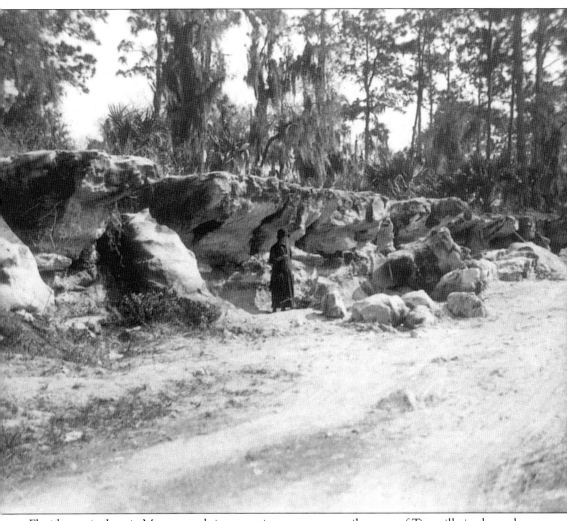

Florida tourist Jennie Meyer stands in a coquina quarry two miles west of Titusville in the early 1920s. Coquina rock was a popular building material in coastal Florida for several centuries. The rock is made of small compressed seashells that, over time, fuse into rock. (Courtesy of the Alma Clyde Field Library of Florida History.)

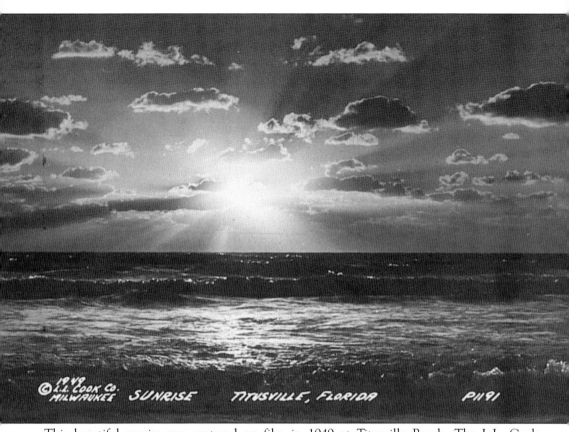

This beautiful sunrise was captured on film in 1949 at Titusville Beach. The L.L. Cook Company of Milwaukee placed this enticing image on a postcard. Natural beauty has drawn tourists to the Titusville area since the late 1800s. (Courtesy of L.L. Cook Co.)

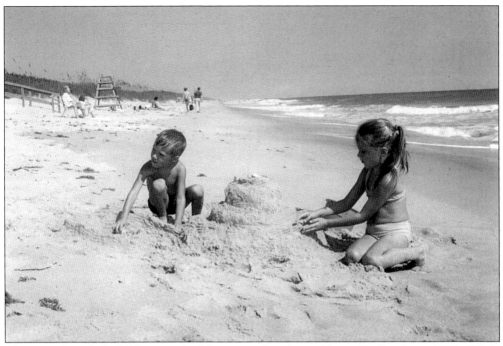

These unidentified children are building a sandcastle on Titusville Beach in 1970. While Titusville Beach is no longer open to the public, there is no shortage of local beaches to enjoy. (Courtesy of Florida State Archives.)

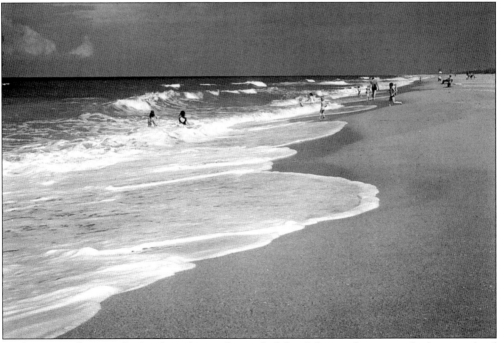

In this 1970 photograph, families play in the surf of the Atlantic Ocean on the barrier island between the Indian River and Titusville. (Courtesy of Florida State Archives.)

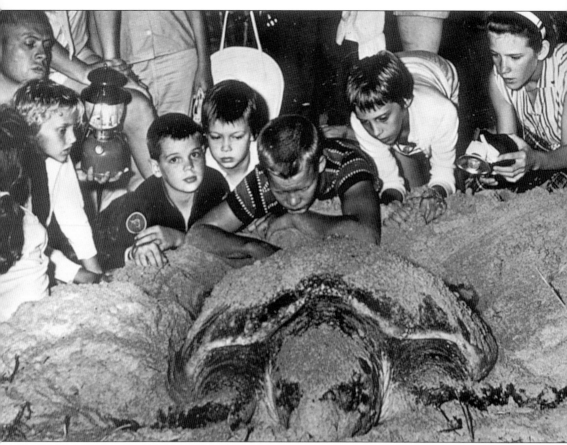

These unidentified children are watching a loggerhead turtle lay her eggs on Titusville Beach in about 1970. Since 1978, the loggerhead turtle has been considered a threatened species. Loggerheads lay their eggs at night. The tiny, two-inch-long hatchlings follow the moonlight to the ocean. In recent decades, man-made lights have attracted the baby turtles, leading them in the wrong direction. Commercial fishing practices and loss of habitat are also causing the turtle population to decline. Florida has more than 90 percent of all loggerhead nesting areas. The three-foot-long turtles grow to weigh between 200 and 350 pounds and lay eggs about every two to three years. (Courtesy of Florida State Archives.)

Loggerhead turtles nest in Florida between April and September. This unidentified couple is witnessing the birth of baby loggerheads on Titusville Beach in 1970. (Courtesy of Florida State Archives.)

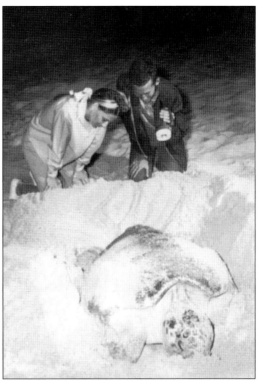

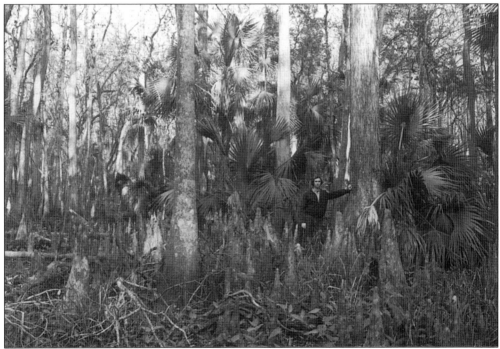

This unidentified man is standing in a cypress forest at the Tosohatchee Tract immediately west of Titusville. The Tosohatchee State Reserve was created in 1977 under Florida's Environmentally Endangered Lands program. (Courtesy of Florida State Archives.)

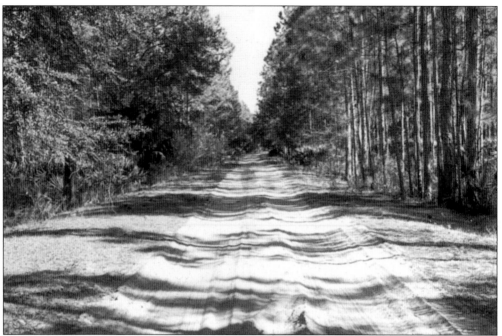

This dirt road is in the Tosohatchee State Reserve, which consists of 28,000 acres that border 19 miles of the St. John's River west of Titusville. The protected lands include swamps, freshwater marshes, pine flatwoods, and hardwood hammocks. (Courtesy of Florida State Archives.)

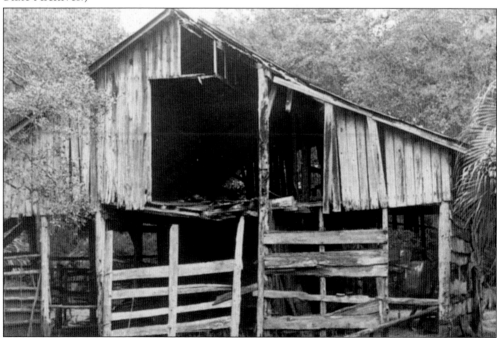

This abandoned barn is on land that is now part of the Tosohatchee State Reserve. The park is open every day year-round and offers nature trails, fishing, boating, camping, and other activities. (Courtesy of Florida State Archives.)

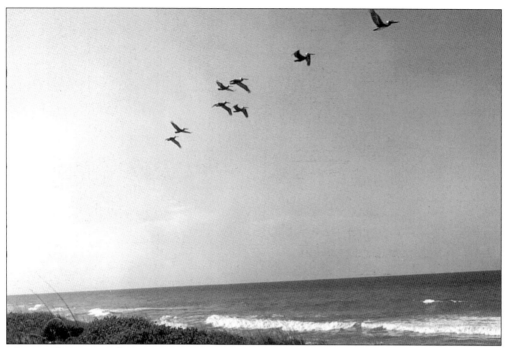

These pelicans are flying over Titusville Beach in 1970. Since 1997, the Brevard Nature Alliance has been presenting the annual Birding and Wildlife Festival on the Titusville campus of Brevard Community College. (Courtesy of Florida State Archives.)

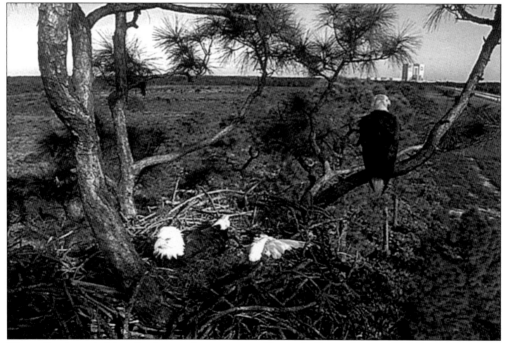

These Southern bald eagles have a huge nest on Kennedy Space Center (KSC) property. This photograph was taken in 1992 using a remote control camera hidden in the pine tree with the nest. It is believed that there are eight or nine active eagle nests at KSC. (Courtesy of NASA.)

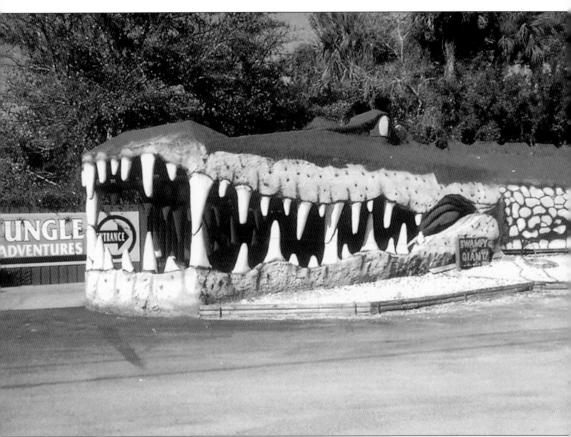

Since the mid-1970s, Swampy the Giant Alligator has been greeting guests at Jungle Adventures, located on State Road 50, seven miles west of Titusville. The 20-acre nature park and wildlife sanctuary offers a view of the "real" Florida not found in the Orlando theme parks. Visitors can hold a baby alligator and see many animals, including turtles, snakes, monkeys, and the endangered Florida panther. A "jungle cruise" goes to a re-creation of a Native American village. (Courtesy of Jungle Adventures.)

Seven

ON THE RIVER

Rivers have always had a romantic appeal. Artists have painted great works inspired by their beauty and composers have written wonderful music when moved by their majesty. Authors and poets have been intrigued by the promise of rivers to sweep us away in their currents to exciting and exotic places. A Chinese philosopher once said: "The mark of a successful man is one that has spent an entire day on the bank of a river without feeling guilty about it." Throughout history, rivers have given us sustenance both physical and spiritual by providing us with food and livelihoods, as well as relaxation and dreams.

The early settlers of Titusville and Mims took advantage of the Indian River, building hotels and homes on its banks and fishing and boating in its waters. The river allowed Titusville to enjoy a brief period as a major transportation hub linking the railroad with steamboat traffic in the late 1800s. Today, the Veteran's Memorial Park honors soldiers of American wars where the trains used to meet boats at the Indian River.

Since 1975, the city of Titusville has hosted the Indian River Festival in April, a four-day event featuring carnival rides, food, arts and crafts, an antique car show, fireworks displays, and a raft race on the river featuring unique, home-made watercraft. The annual event is held by the river in Sand Point Park. From the establishment of the community to the present day, the Indian River brings the people of Titusville and Mims together.

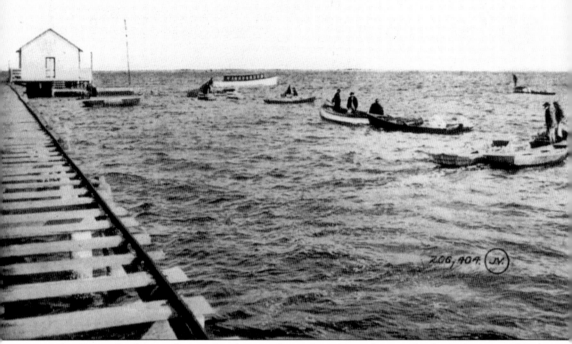

The Titusville fishing fleet is hard at work in the 1880s. George Scobie's Oyster and Fish Company had 30 boats that worked the Indian River. On the left of this photograph is a dock with railroad tracks on it. This dock extended about 1,500 feet into the river to take trains to the steamship wharf. Produce and other products could then be loaded easily from the trains to the steamships. (Courtesy of the Brevard County Historical Commission.)

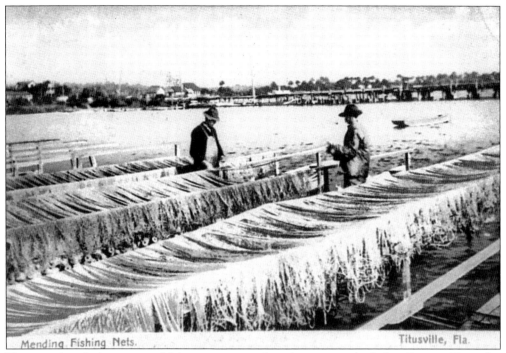

Mending Fishing Nets. Titusville, Fla.

These unidentified commercial fishermen are mending their nets in the Indian River at Titusville. This photograph was taken in 1909. (Courtesy of the Brevard County Historical Commission.)

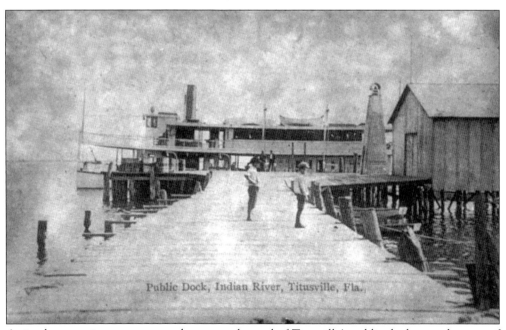

Public Dock, Indian River, Titusville, Fla.

A riverboat awaits passengers and cargo at the end of Titusville's public dock near the turn of the century. (Courtesy of the Brevard County Historical Commission.)

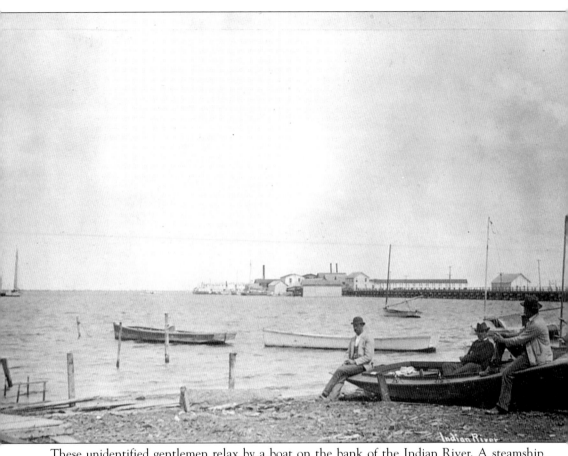

These unidentified gentlemen relax by a boat on the bank of the Indian River. A steamship can be seen at the end of the pier in this photograph from the 1890s. By the mid-1890s, Henry Flagler's Florida East Coast Railway had pushed through Titusville and advanced farther south. Steamships continued to stop at Titusville regularly into the next century, but eventually trains attracted too many riders to keep the passenger ships in business. (Courtesy of Florida State Archives.)

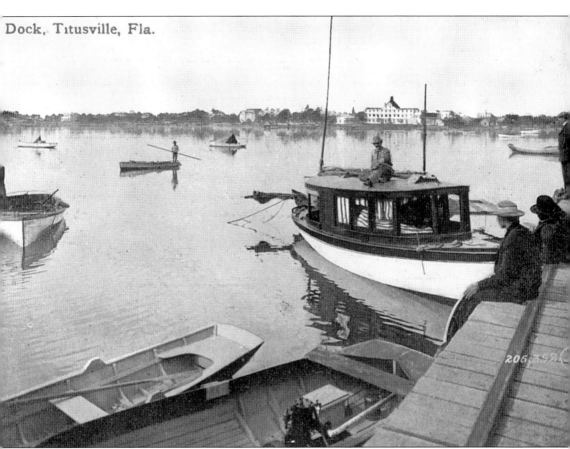

Dock, Titusville, Fla.

This photograph from before 1910 shows the Indian River at Titusville being used for both business and pleasure. While tourists relax on the right, commercial fishermen work the river on the left. The Indian River Hotel can be seen in the background. Today, fishing boats are still used on the Indian River both vocationally and recreationally. (Courtesy of Florida State Archives.)

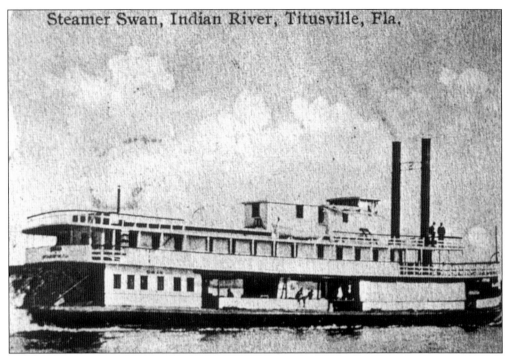

The paddle-wheel steamboat the *Swan* stopped in Titusville regularly in the late 1800s and early 1900s, moving passengers and cargo up and down the Indian River. (Courtesy of Florida State Archives.)

The paddle-wheel steamship *Santa Lucinda* was formerly known as the *Nellie Hudson*. In the 1890s, Henry Flagler had the ship brought to Florida from Pittsburgh to transport materials south to build the Royal Poinciana Hotel. The steamer made a 3,000-mile trip down the Ohio River, the Mississippi River, around Cape Sable, and through Jupiter Inlet to Titusville. (Courtesy of Florida State Archives.)

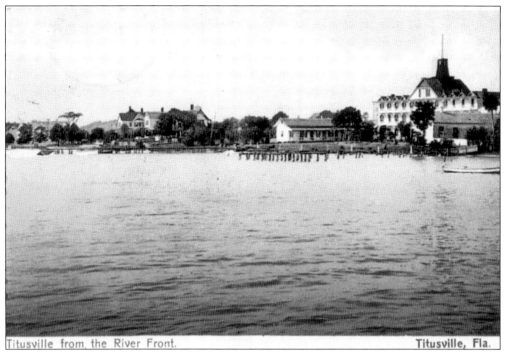

Titusville from the River Front. Titusville, Fla.

This is how steamboat passengers would first see Titusville as they approached on the Indian River. The Indian River Hotel is on the right in this 1907 photograph. (Courtesy of Florida State Archives.)

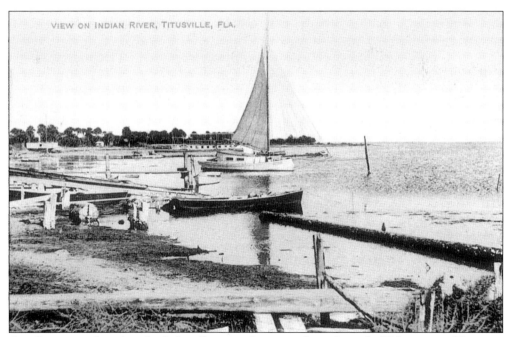

VIEW ON INDIAN RIVER, TITUSVILLE, FLA.

A sailboat is anchored in the Indian River in this image from the early 20th century. (Courtesy of Florida State Archives.)

During World War II, military personnel would patrol local beaches looking for German submarines. After a patrol, a group of six soldiers returning to Titusville accidentally drove their truck over Walker Bridge and drowned. (Courtesy of Florida State Archives.)

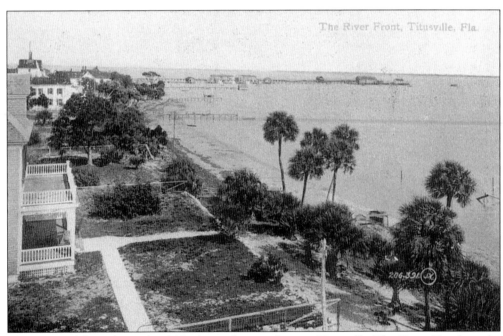

This postcard from the early 1900s shows the riverfront at Titusville. The Dixie Hotel can be seen in the upper left corner. (Courtesy of Florida State Archives.)

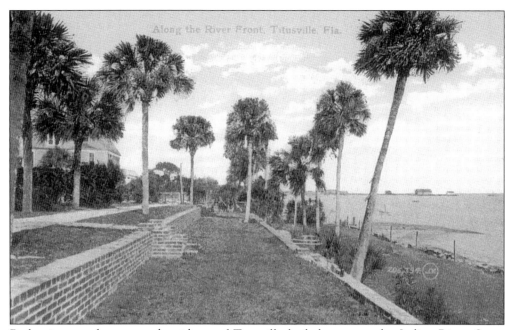

Both winter and year-round residents of Titusville built homes on the Indian River. Some built landscaped terraces to take them down to the water's edge. (Courtesy of Florida State Archives.)

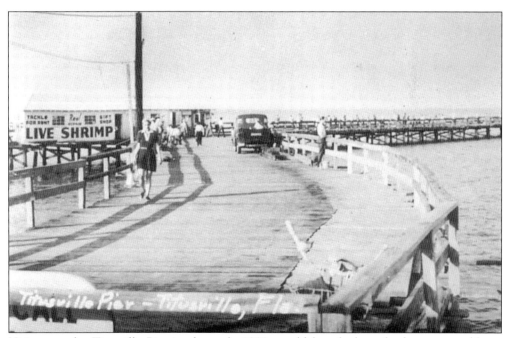

Visitors to the Titusville Pier in the early 1900s could buy fresh seafood or rent tackle to catch their own. This photograph was taken in 1949. (Courtesy of the Brevard County Historical Commission.)

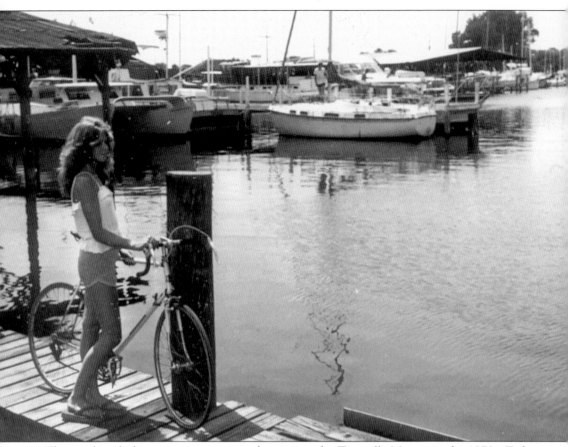

This unidentified young woman enjoys the view at the Titusville Marina in the 1970s. Today, Space Coast Nature Tours departs from the marina, giving 90-minute tours of the Indian River Lagoon. Charter fishing boats leave from the marina as well, guiding fisherman to trout, redfish, tarpon, snook, and other varieties of fish. Private boats also dock here. (Courtesy of Florida State Archives.)

Eight

BE OUR GUEST

Approximately 2.5 million tourists visit North Brevard County annually, joining the 41,000 residents of Titusville and the 9,200 people who live in Mims. Much of the area's economy is based on providing these visitors with some place to stay, food to eat, and entertaining activities. Most of the people who visit Titusville and Mims are coming to see the Kennedy Space Center and tour its facilities. Lucky visitors are able to schedule their vacations to coincide with a shuttle launch. Any visitor is awed, standing on the public dock in Titusville, watching the shuttle's solid rocket boosters turn night into day and hearing their powerful rumble roll across the Indian River. Many visitors also come to enjoy the Merritt Island National Wildlife Refuge, the Canaveral National Seashore, and the area's other natural attractions.

Long before the existence of the Kennedy Space Center, tourists had been coming to Titusville and Mims in large numbers. As early as the 1870s, wealthy Northerners escaped harsh winters to stay in the Dixie Hotel, the Indian River Hotel, the Palmhurst Hotel, and other hotels that were built in the early 1900s. The fact that Titusville was easily accessible by train and steamship made it a popular destination. In the early 1920s, "Tin Can Tourists" jumped in their automobiles and came to Titusville and Mims looking for adventure. Nothing, though, could prepare local residents for the influx of people that would accompany America's space program to the area.

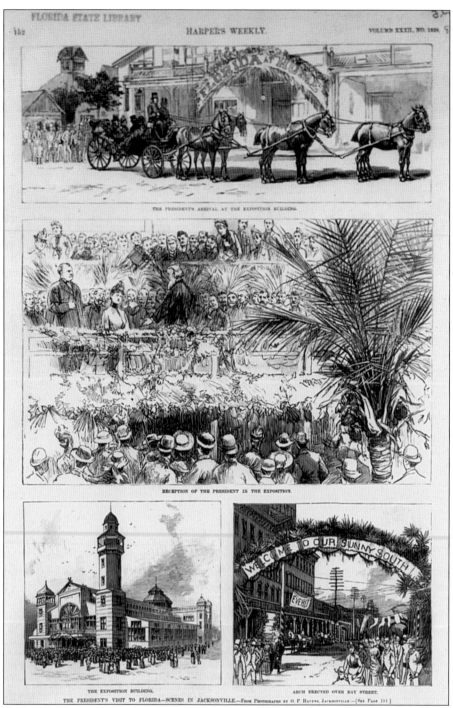

President Grover Cleveland visited Titusville in February of 1888. These drawings depict President Cleveland and his party in Jacksonville. After attending the exposition in Jacksonville, Cleveland spent the night in St. Augustine before traveling to Palatka and Titusville. The president boarded a steamship in Titusville, visiting Rockledge and Sanford before returning to Washington, D.C., from Jacksonville. (Courtesy of Florida State Archives.)

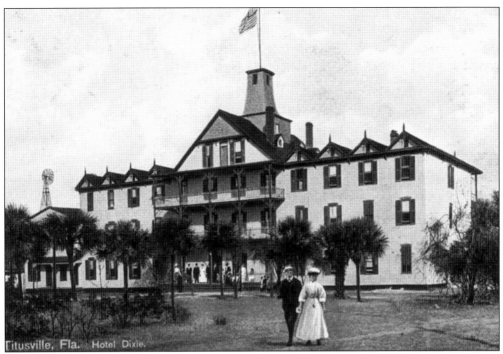

The Dixie Hotel was built in 1890 on the Indian River. The hotel was constructed on the site where Henry Titus built his home in 1870. This image of the hotel is from 1909. (Courtesy of Florida State Archives.)

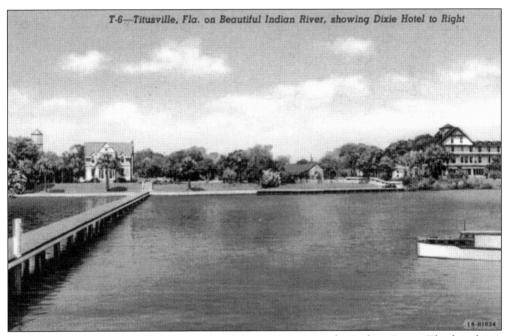

The Dixie Hotel is pictured here on the right, as seen from the Indian River. The hotel was destroyed by fire in 1962 and replaced with the Titusville Towers, an assisted living facility. (Courtesy of Florida State Archives.)

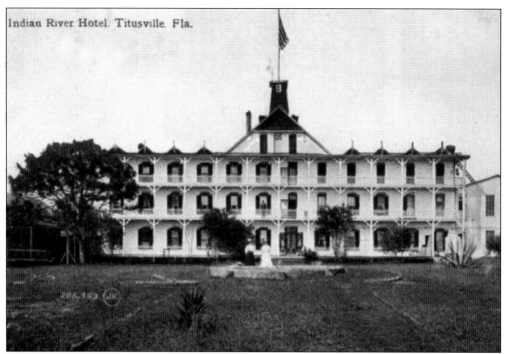

Col. Henry Titus, the founder of Titusville, built the Indian River Hotel in 1869. This photograph is from 1909. (Courtesy of Florida State Archives.)

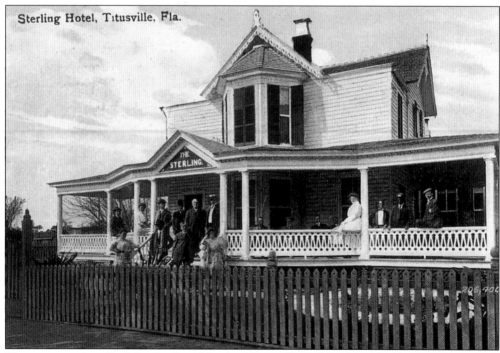

The guests and staff of the Sterling Hotel in Titusville gathered on the front porch for this photograph in 1910. (Courtesy of Florida State Archives.)

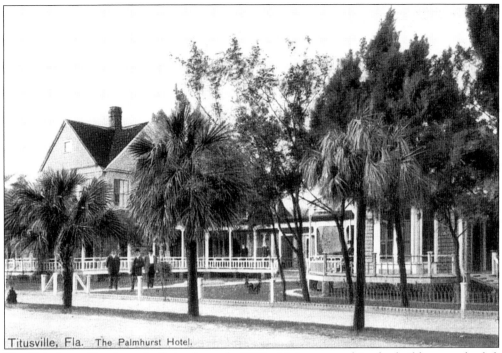

The Palmhurst Hotel was built in the early 1900s. Visitors stayed in the building on the left and the dining room was in the building on the right. After years of neglect, the hotel was torn down in the 1980s. (Courtesy of Florida State Archives.)

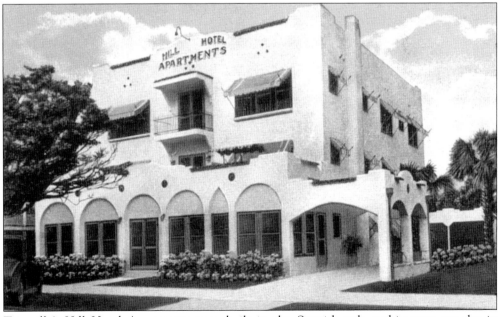

Titusville's Hill Hotel Apartments were built in the Spanish-style architecture popular in Florida in the 1920s, when this photograph was taken. (Courtesy of Florida State Archives.)

Not all visitors to Titusville in the early 20th century stayed in hotels. This photograph from the early 1920s shows the Meyer family, part of a group of travelers called the "Tin Can Tourists," camping at the Thatcher family house in Titusville. The Tin Can Tourists were a new breed of traveler inspired by the freedom offered by automobiles. (Courtesy of the Alma Clyde Field Library of Florida History.)

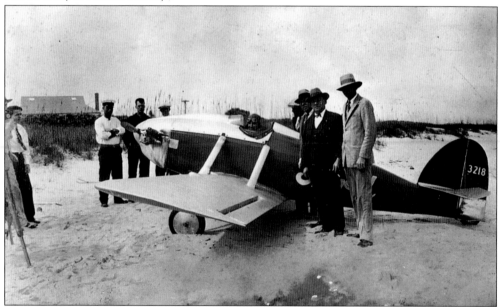

Car manufacturer Henry Ford introduced the prototype for a new, affordable, small aircraft in 1926. Ford asked test pilot Harry Brooks to take the new airplane on a publicity tour of Florida. On February 21, 1928, Brooks made this unscheduled stop in Titusville. Two days later, he crashed into the sea off Melbourne. Brooks is shown here in the cockpit of the plane. The man standing on the far right is J.W. Hanson, news editor of the *Star Advocate*. (Courtesy of Florida State Archives.)

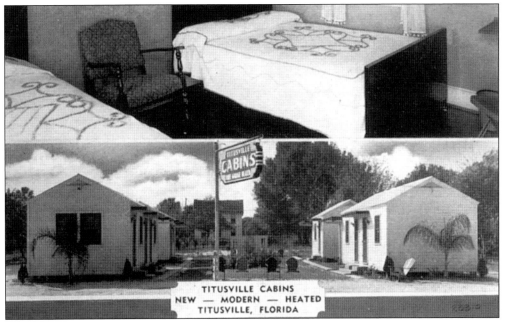

In the mid-20th century, Titusville Cabins offered visitors "Continuous Hot and Cold Running Water and Innerspring Mattresses." Each cabin also had a private bath. (Courtesy L.L. Cook Co.)

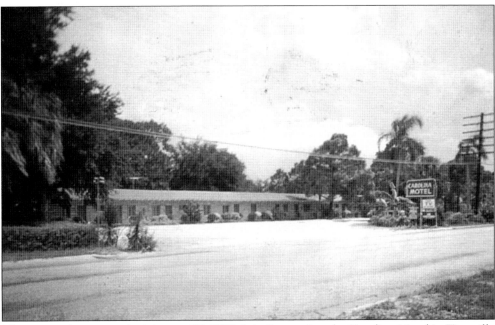

This postcard is postmarked August 27, 1957. It indicates that the Carolina Motel in Titusville was air-conditioned and each room had a television. (Courtesy of Henry H. Ahrens.)

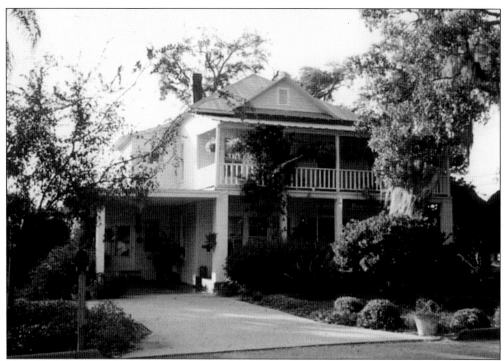

This home was built about 1860 in Mims and is listed on the Brevard Register of Historic Buildings. In 1998, Bill and Ursula Dickens opened a bed and breakfast in the home called the Dickens Inn. (Courtesy of Dickens Inn.)

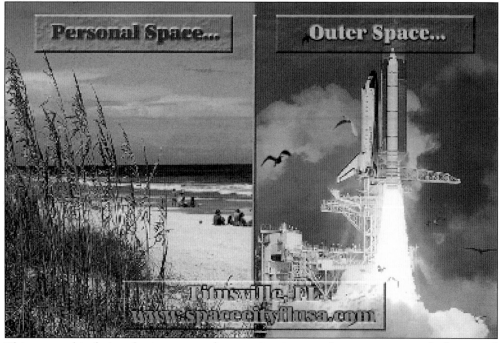

This postcard is designed to attract modern tourists interested in ecotourism and educational side trips, as well as fun in the sun. (Courtesy of Titusville Area Chamber of Commerce.)

Nine

THE HARRY T. MOORE LEGACY

Harry Tyson Moore was born on November 18, 1905, in Houston, Florida, located in Suwannee County. Moore moved to Mims in 1925 after being offered a job to teach fourth grade at the black elementary school in nearby Cocoa. At age 19, Moore graduated with a high school diploma from Florida Memorial College where he was a straight-A student, except for a B+ in French. Other students called him "Doc" because he did so well in all his classes. Later, Moore, his wife Harriette, and both of their daughters, Peaches and Evangeline, graduated from Bethune-Cookman College in Daytona. Harry T. Moore was a studious, serious, religious, and soft-spoken young man. Few would have guessed that the quiet and polite Harry T. Moore would lead a highly successful effort to expand black voting registration, dramatically increase membership in the Florida branch of the NAACP, work for equal justice for African Americans, and actively seek punishment for those who committed crimes against them.

Harry T. Moore's efforts on behalf of black people cost him his life and that of his wife Harriette. Moore's murder made international headlines the next day and was the subject of newspaper editorials around the world. Ironically, Harry T. Moore and his efforts would largely be forgotten as the modern American Civil Rights movement progressed. The Brown v. Board of Education case that ended racial segregation in 1954 is often identified as the beginning of the Civil Rights movement. Since Harry T. Moore was assassinated in 1951, his legacy is often, mistakenly, overlooked.

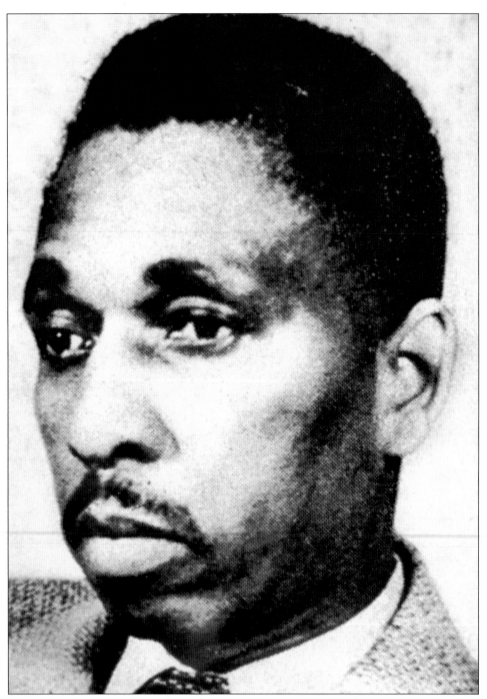

Mims resident Harry T. Moore, shown here in 1945, was a Civil Rights pioneer in Florida. As a ninth-grade teacher and principal at Titusville Negro School, he instilled in his students a sense of pride and a solid work ethic. Eventually Moore became director of the Florida branch of the NAACP, working throughout the state for the integration of schools, improved voting rights for African Americans, and equal treatment for blacks in the legal system. (Courtesy of Florida State Archives.)

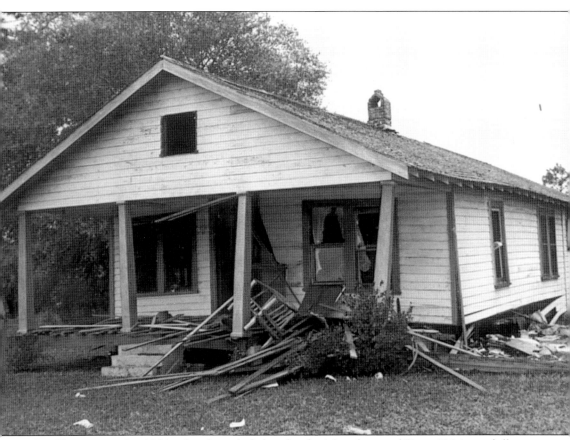

On Christmas night, 1951, a bomb exploded under the Mims home of Harry T. Moore, killing him. His wife Harriette died nine days later from injuries sustained in the blast. That night also happened to be the Moores' 25th wedding anniversary. The explosion, the effects of which are visible in this photograph, was heard several miles away in Titusville. The murders remain unsolved, but many believe the Moores were killed by members of the Ku Klux Klan in retaliation for Mr. Moore's support of four young black men accused of raping a white woman in the notorious Groveland case. (Courtesy of Florida State Archives.)

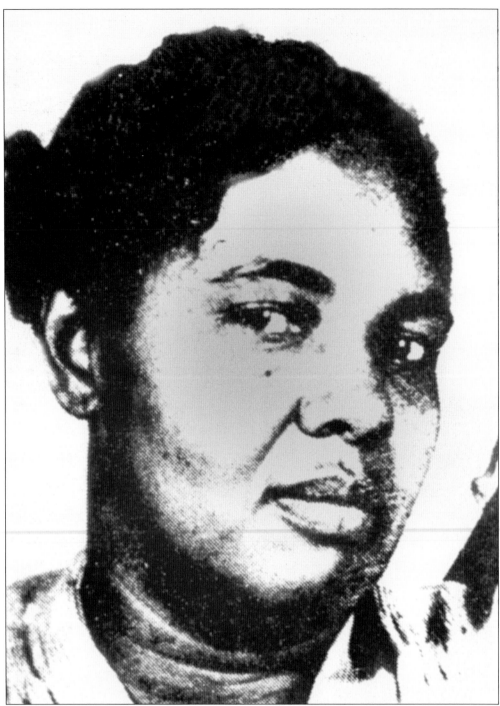

Harry T. Moore met Harriette Vyda Simms in 1925, the first year he taught school in Brevard County. The two met while playing the card game bid whist, reportedly Mr. Moore's only vice. Harriette was also a teacher, but she was selling insurance for a black-owned company when she and Harry met. The two were married the next year on Christmas day. Harriette is pictured here in about 1945. (Courtesy of Florida State Archives.)

Harriette V. Moore steps on the running board of the family car. Harry T. Moore liked to drive his family to Daytona Beach and Orlando on Saturdays to see movies and patronize black-owned businesses, more plentiful in those cities. Moore also drove all over the state encouraging African Americans to vote. (Courtesy of the Moore Cultural Complex.)

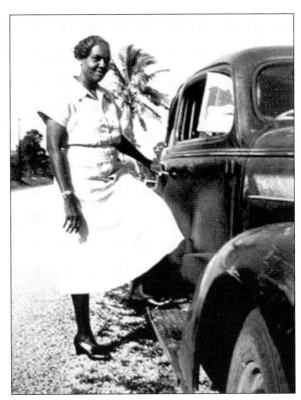

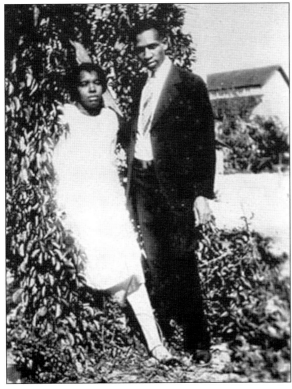

This photograph of Harry T. and Harriette V. Moore was taken in 1927, about one year after they were married. (Courtesy of the Moore Cultural Complex.)

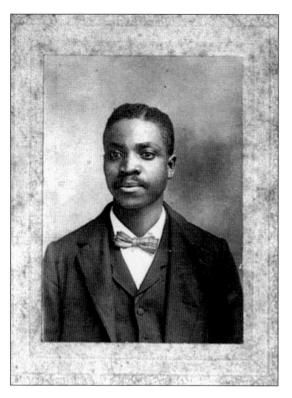

Pictured here is Harry T. Moore's father, S.J. Moore, who died when Harry was nine years old. In 1915, a year after Harry's father died, Harry was sent to Daytona to attend school. A year later, he moved to Jacksonville, the biggest city in Florida. (Courtesy of Evangeline Moore.)

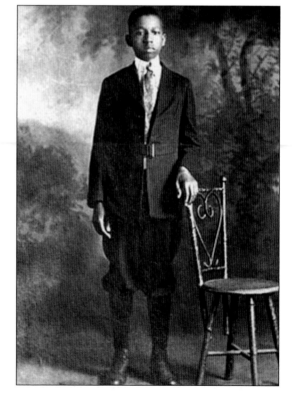

When Harry T. Moore was 13 years old, he lived in Jacksonville with his three aunts, who were all professional, educated women. Jessie Tyson was a nurse, Adrianna Tyson was a junior high school principal, and Masie Tyson was a college instructor with a Ph.D. in geography. The women encouraged Harry to excel academically. (Courtesy of Evangeline Moore.)

In 1927, Harry T. Moore was promoted to principal of the Titusville Negro School where he also taught ninth grade. Moore would bring his own books and materials to his classes to augment the worn and torn hand-me-downs from the white schools. (Courtesy of Evangeline Moore.)

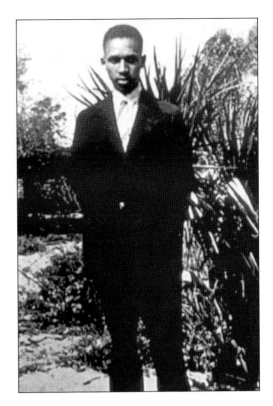

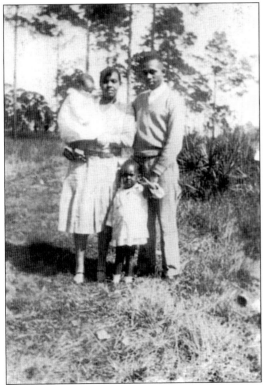

This photograph shows the Moore family in the 1930s. Harriette Moore is holding their daughter Evangeline while daughter Peaches stands in front of her father, Harry. Harriette took some time off for the births of her daughters but eventually returned to teaching. (Courtesy of Evangeline Moore.)

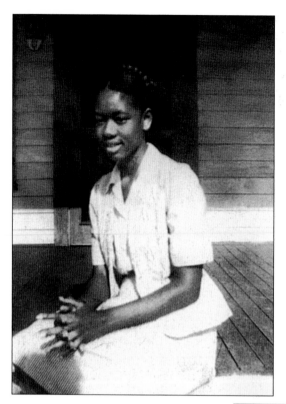

Evangeline Moore sits on the steps of the family home in Mims. From the age of 12 or 13, Evangeline remembers helping her father with his NAACP mailing lists and even delivering speeches as a teenager at the Florida State Conference conventions. (Courtesy of Evangeline Moore.)

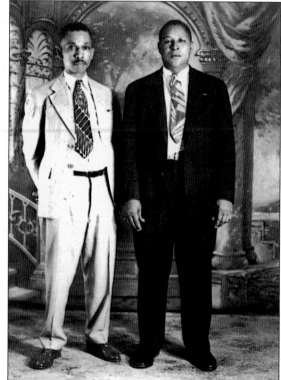

In addition to serving as Florida coordinator of the NAACP, Harry T. Moore (left) co-founded the Progressive Voters' League in 1944. By 1951, that organization registered 100,000 new black voters. (Courtesy of Evangeline Moore.)

A teenage Evangeline Moore (left, standing) joins her mother Harriette, father Harry, and Claudia Holland in Fort Lauderdale. Sitting are two unidentified NAACP colleagues. (Courtesy of Evangeline Moore.)

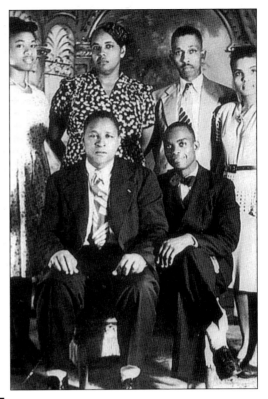

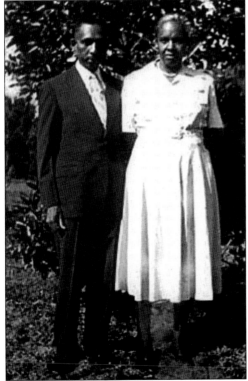

Harry T. and Harriette V. Moore are shown here not long before they were killed on Christmas night, 1951, by a bomb exploding under their home in Mims. (Courtesy of Evangeline Moore.)

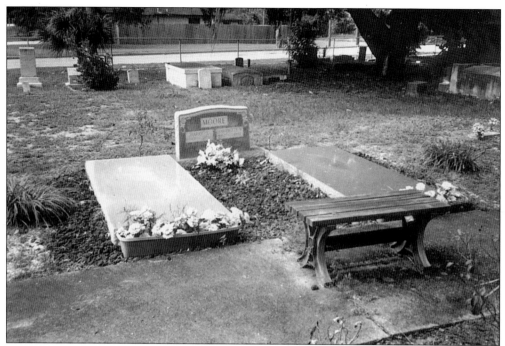

Harry T. and Harriette V. Moore are buried in the "black section" of the LaGrange cemetery, a short distance from the grave of Henry Titus, founder of Titusville and a supporter of slavery. (Courtesy of Evangeline Moore.)

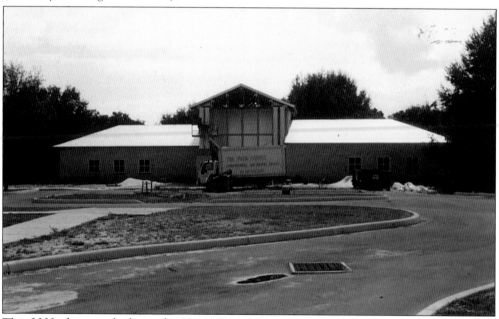

This 2003 photograph shows the Harry T. and Harriette V. Moore Cultural Complex under construction on the Moore homesite in Mims. The educational center will keep the Moore legacy alive, remembering the past to make the future better. The Moore Cultural Complex and Brevard Community College present the annual Moore Heritage Festival of the Arts and Humanities. (Courtesy of the Moore Cultural Complex.)

Ten

SPACE CITY, U.S.A.

The mid-20th century was a very exciting time in Titusville and Mims. The establishment of Patrick Air Force Base to the south and a long-range missile program at Cape Canaveral in the 1940s brought tremendous growth to the area. By 1959, the newly-formed National Aeronautics and Space Administration (NASA) was successfully launching lunar probes in preparation for the manned exploration of space.

The local population statistics from this time are dramatic. Between 1950 and 1960, the population of the state of Florida increased 78.7 percent, from 2.8 million to 4.9 million. At the same time, the population of Brevard County exploded 371.1 percent, from just 23,000 to 111,435. All of this activity and growth brought new jobs to the region.

Every American manned mission in space has been launched from the Kennedy Space Center (KSC). From the beginning of the space program to the present day, Titusville has been the best vantage point to watch a launch from KSC. Even after more than three decades, when a launch is scheduled, the people of Titusville and Mims walk out of their homes and into their yards, or out of their places of business or schools, and look to the east. They watch the amazing spectacle of human beings using the latest technology to leave our planet and explore the universe, taking our hopes and dreams for the future with them.

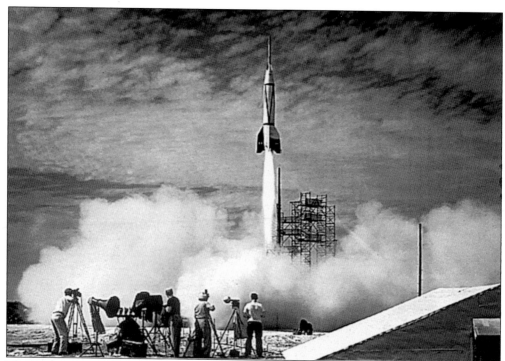

The Bumper V-2 missile was the first rocket launched from Cape Canaveral on July 24, 1950. From the day that this first missile was sent into space, the residents of Titusville and Mims have enjoyed front row seats to NASA launches. (Courtesy of NASA.)

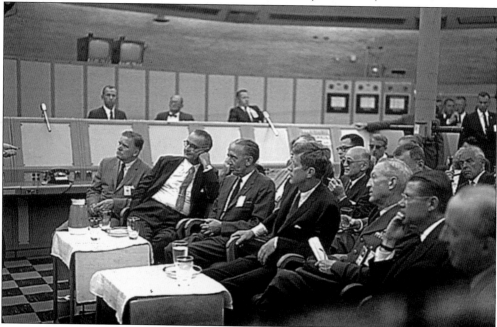

President John F. Kennedy (front row, fourth from left) is being briefed by Maj. Rocco Petrone in this photograph from September 11, 1962, during a tour of Blockhouse 34 at the Cape Canaveral Missile Annex. (Courtesy of NASA.)

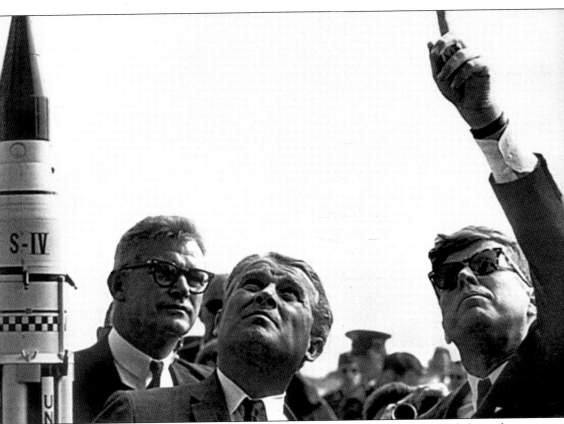

On May 25, 1961, President John F. Kennedy told a joint session of Congress: "I believe that this nation should commit itself to achieving the goal, before this decade is out, of landing a man on the moon and returning him safely to the earth." Although Kennedy did not live to see it, that goal was achieved when Neil Armstrong took mankind's first step on the moon on July 20, 1969. Here President Kennedy (right) talks with NASA Deputy Administrator Dr. Robert C. Seamans (left) and rocket engineer Dr. Wernher von Braun (center) about the Saturn rocket launch system. This photograph was taken at Cape Canaveral on November 16, 1963, six days before the president was assassinated in Dallas. (Courtesy of NASA.)

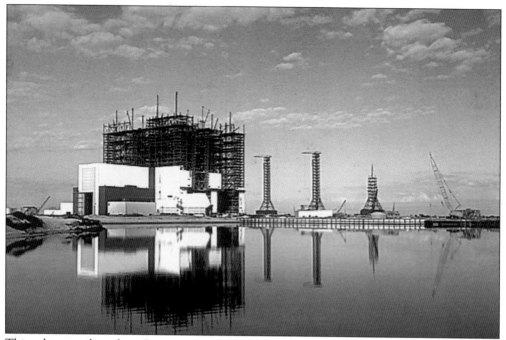

This photograph, taken January 5, 1965, shows the Vehicle Assembly Building under construction at the Kennedy Space Center (KSC). This building can be seen from Titusville. (Courtesy of NASA.)

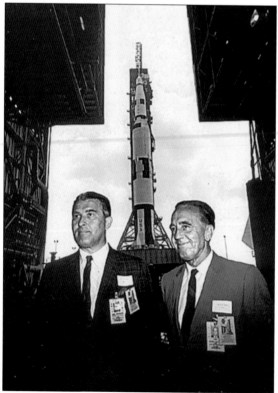

Dr. Wernher von Braun (left) and Kennedy Space Center Director Dr. Kurt Debus (right) observe the rollout of the Saturn 500F from the Vehicle Assembly Building on May 26, 1966. (Courtesy of NASA.)

The Project Mercury Astronauts prepare to achieve their goal to orbit a manned spacecraft around the earth, to investigate man's ability to function in space, and to recover both man and spacecraft safely. The Mercury astronauts are, from left to right, (front row) Walter H. Schirra Jr., Donald K. Slayton, John H. Glenn Jr., and Scott Carpenter; (back row) Alan B. Shepard Jr., Virgil I. Gus Grissom, and L. Gordon Cooper. (Courtesy of NASA.)

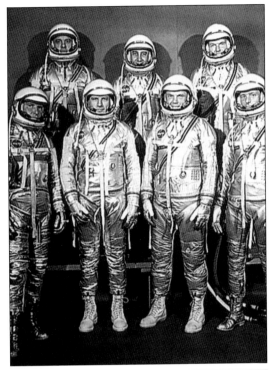

This monument to the seven Mercury astronauts is located in Titusville's Space Walk of Fame on the Indian River. Other monuments recognize the Gemini and Apollo missions. (Courtesy of the Space Walk of Fame.)

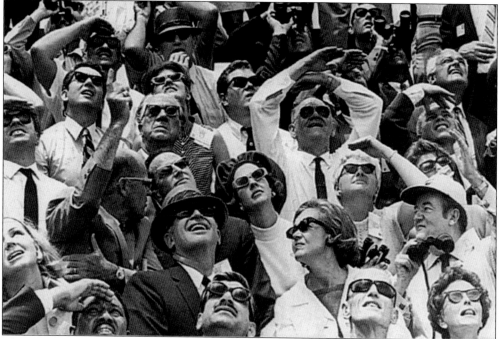

The liftoff of *Apollo 10* on May 18, 1969, is observed by KSC Deputy Director of Administration Albert Siepert (seated left, pointing up), King Baudouin and Queen Fabiola of Belgium (seated next to Siepert), and former U.S. Vice President Hubert Humphrey (right, in baseball cap). (Courtesy of NASA.)

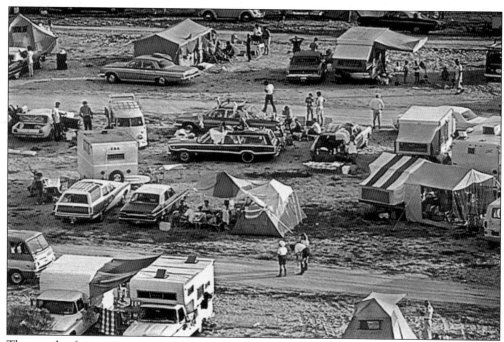

Thousands of spectators camp out in and around Titusville and Mims to watch the *Apollo 11* liftoff on July 16, 1968. (Courtesy of NASA.)

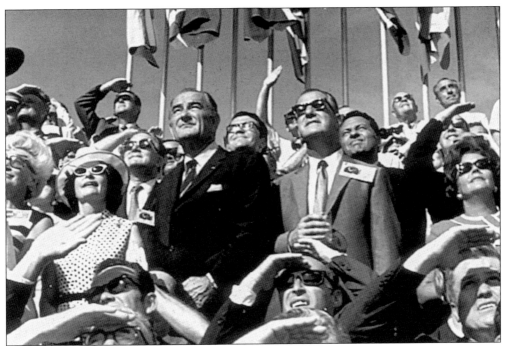

With a slightly better view than the campers, Vice President Spiro Agnew and former President Lyndon B. Johnson watch the liftoff of *Apollo 11* from launch pad 39A at KSC. (Courtesy of NASA.)

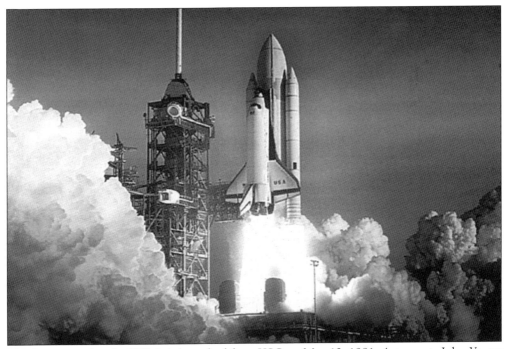

The first space shuttle, *STS-1*, is launched from KSC on May 12, 1981. Astronauts John Young and Robert Crippen are on board. (Courtesy of NASA.)

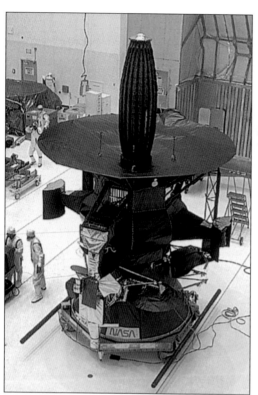

Space shuttle *Atlantis* took the *Galileo* spacecraft into space on October 12, 1989. It was estimated that it would take *Galileo* more than six years to reach Jupiter. (Courtesy of NASA.)

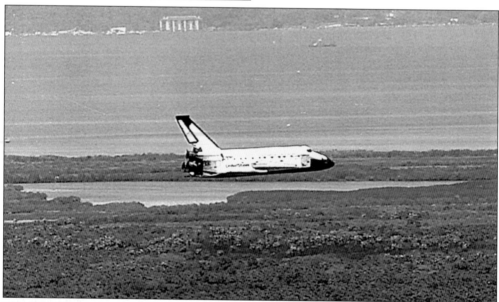

The city of Titusville can be seen clearly in this unusual view of the shuttle Columbia landing at the Kennedy Space Center on May 3, 1998. The photograph was taken from the roof of the Vehicle Assembly Building, 525 feet above ground. The angle shows the Indian River and the city of Titusville behind the shuttle. Tragically, the shuttle *Columbia* exploded 38 miles above the earth on February 1, 2003, just 15 minutes before its scheduled landing at KSC. (Courtesy of NASA.)

The space shuttle *Endeavor* is rolled out of the Vehicle Assembly Building and taken to the launch pad. The shuttle, without its payload, weighs about 4.5 million pounds. (Courtesy of NASA.)

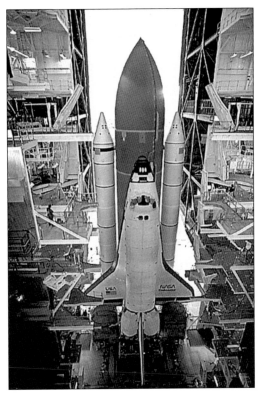

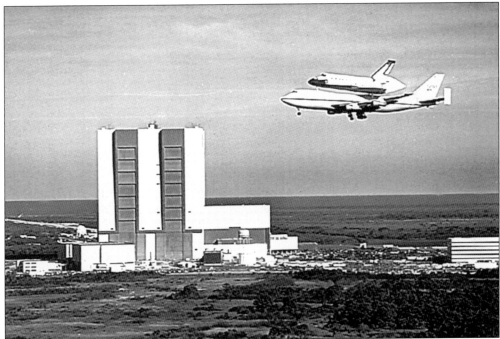

A familiar sight to residents of Titusville and Mims, the space shuttle *Columbia* returns to KSC from Edwards Air Force Base in California aboard the Shuttle Carrier Aircraft. The Vehicle Assembly Building is in the background. (Courtesy of NASA.)

The past meets the future in this photograph from June 13, 1972. The Cape Canaveral Lighthouse, built in 1847, stands sentinel as an Atlas-Centaur space vehicle is launched from the Kennedy Space Center carrying an Intelsat Communications Satellite. The lighthouse was once the centerpiece of a thriving community that was displaced when the Cape Canaveral Air Force Station was built. The lighthouse has been automated since the 1950s. (Courtesy of NASA.)